Portraits of Babies & Children

Giovanni Civardi

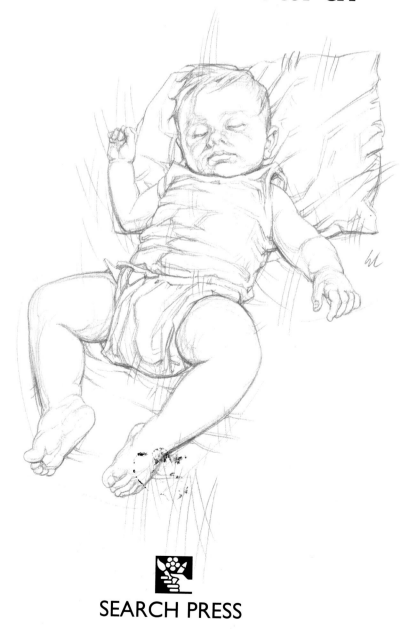

SEARCH PRESS

Giovanni Gugliemo Civardi was born in Milan in 1947. After dedicating himself to illustration, portraiture and sculpture, he has been interested in anatomy for artists for many years and holds human body drawing courses.

First published in Great Britain in 2017 by
Search Press Limited, Wellwood, North Farm Road,
Tunbridge Wells, Kent TN2 3DR

Originally published in Italy by Il Castello Collane
Techniche, Milano

Copyright © Il Castello S.r.l., via Milano 73/75 20010
Cornaredo (Milano) Italy, 2015 *Diesgnare Volti di
Neonati e Bambini*

English translation by Burravoe Translation Services

ISBN: 978-1-78221-316-1

The Publishers and author can accept no responsibility for any consequences arising from the information, advice or instructions given in this publication.

Printed in Malaysia

CONTENTS

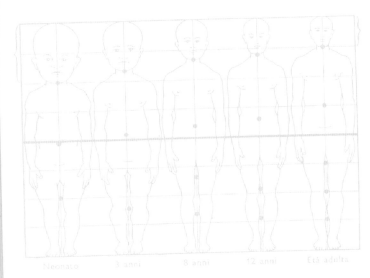

The drawings of faces in this book are all of subjects who have given their permission or have been authorised by persons responsible for them in the family, for which I thank them. Any likeness with other people or with other children is a mere coincidence. In all cases, for reasons of confidentiality regarding identification, I have deliberately altered facial features a little so that they are not a perfect likeness. *G.C.*

(To Giuseppe di Stefano, a comfort and guide in art and life.)
Whatever the reader can do, leave to the reader.
Ludwig Wittgenstein

There are those who repeat tradition and those who open new avenues. The great artist does both.
You begin with the description.
Galileo Galilei

Becoming is easy, staying that way is hard.
Maria Callas

INTRODUCTION

Children, like young animals, stimulate an instinctive sense of tenderness and protectiveness in adults, because of those typical features that characterise the head and face of the human infant: round head, big eyes, a small, rounded nose, chubby cheeks, small mouth and chin, curved forehead, soft, clear skin, and a tiny neck. It is no surprise that everyone loves children: there is, perhaps, no other moment of a person's life when they are so often observed, photographed and drawn. In fact, drawing and painting children, especially in their earliest years, is almost a special branch of art. The painter, illustrator and sculptor are often called upon to include these subjects in their work. When creating a child's 'portrait', the drawing (the quickest technique, compared to painting, and more in line with the freshness of youth and a child's tiny form) brings forth different problems to those posed by the individual adult. And yet, if the structure and proportions characteristic of each growing stage of the child's head are correctly understood and represented, the work is not impossibly difficult. When drawing children's faces, try to feel empathy for them and rely on the study of superficial shapes, rather than being dominated by the strict rules of 'construction' or by anatomical data, and avoid being drawn in and satisfied by the pleasure of a technical, analytical work to the point where you lose the aesthetic effect of spontaneous simplicity. Children's heads are such delicate forms that if an attempt is made to copy the more subtle and blended tones of chiaroscuro too accurately, the final result may be one of volumetric weakness.

In this book, I have tried to gather together the main information that can be useful as an initial guide in practising observation, evaluation (and, in the drawing of children's heads, not necessarily of 'portraits') of the special details of anatomy, proportion and psychological development that mark childhood (which, by convention, last until the age of about six or seven years old), and that are of deep interest for the artist now as they were in the past. When looking through images in the history of both Western and Eastern art, we can easily see how the portrayal of children and infants has undergone significant changes in frequency, style and expression. For example, in ancient civilisations such as Egypt, Greece and Mesopotamia, and in the early centuries of the Christian age, children (presented as cupids or winged spirits) were rarely portrayed and usually appeared as a homunculus, a 'small man' or a 'miniature' adult. From the Renaissance to the Baroque period, the portrayal of children was more realistic, faithful to anatomic and morphological detail and also expression. They were more frequent too, with a profusion of cupids, cherubs, angels, the birth of Jesus, etc. From the 19th century onwards, and partly due to the arrival of photography, there has been a greater 'social' attention to children in the artistic trend of realistic or symbolic aesthetics, represented in typical scenes (at play, rural environment, maternity, etc.) or in actual family portraits.

In addition to being enjoyable, drawing children's faces can also become a rewarding source of income: many parents, grandparents and relatives still want and commission a portrait of their children to place alongside the several photographs (now stored on their laptop) so that they have a better, more affectionate and spontaneous souvenir of a moment during such a magical age.

'Who shows a child just as they are? Who sets it in its constellation and gives the measure of distance into its hand?'
Rainer Maria Rilke

PRACTICAL CONSIDERATIONS

Equipment, supports and techniques

The most common, simple traditional drawing techniques such as graphite, charcoal and coloured pencils are essential resources for drawing quick, live sketches, but are also suited to more elaborate drawings. If the small model stays still, on the other hand, or if drawn from a photograph, other techniques can be used, including painting techniques (pastels, watercolours, acrylic, oils and so on) that can explore the chromatic aspect of the model.

As a child's forms are delicate and the shadows formed are soft, techniques that are by their very nature simple to carry out may be more appropriate, reflecting this characteristic and producing a careful, detailed work that is at the same time light, and essential to its overall effect.

Small notebooks can be used for preliminary sketch work, but for more detailed work it is preferable to use (depending on the technique used) more robust supports such as Bristol board, drawing board, a canvas panel, or a good weight and slightly rough paper that is white or coloured.

Children's portraits should be smaller than the natural size (about one-half to two-thirds) otherwise there is a risk of achieving an unpleasant effect of ageing the subject. Therefore, if only the head is drawn, the dimensions of the support must be about 40 x 50 or 50 x 60 centimetres (15¾ x 19¾ or 19¾ x 23½ inches).

In almost all cases, the aesthetic result of freshness so characteristic of a child's face is better if the additional elements surrounding the subject are omitted, leaving a predominantly neutral background, with a head only, with a slight hint of the neck, shoulders and clothes.

Where to find subjects

Children are everywhere: it is easier to observe and gain the participation of children belonging to the artist's family, but also those of friends and acquaintances.

Places where children gather (nurseries, primary schools, parks and gardens, beaches, etc.) are ideal for studying children's actions and their most typical, spontaneous expressions.

In all cases (even if it is a portrait requested by the parents), it is necessary to strictly respect the need for privacy: before entering or stopping in gathering places, you must explain your purpose of action to the persons responsible for guarding or watching over the area, and ask their permission and help and above all, do not directly approach the children that have attracted your artistic attention. In addition to common rules of clear conduct, there are cultural traditions and laws in many countries to protect young subjects and their image. There are customs and regulations that must be known, read and strictly adhered to.

Scientific or educational documentaries, television shows, newspapers or magazines (in particular the ones that include advertising images and concern themselves with health, wellness or fashion and so on) offer a large number of photographs of babies and young children. It would also be possible to take images of this type from the Internet,

but as this is an extremely delicate subject, it is prudent and preferable to avoid this type of search. Drawings can only be made from published photographs for personal, private artistic practice and not for commercial use, as these sources are almost always subject to copyright.

How to behave with children (when drawing or photographing them)

Children are extremely sensitive and unpredictable. It is necessary to be empathic, spontaneous and loving with them. It is also helpful to have some idea about the typical behaviour of these initial development stages (favourite games and exploring the environment; expressions of desires, needs, feelings, tantrums and reactions to stimuli; independence or relations with strangers, etc.).

Formal portraits of children, such as ones done in the artist's studio and while posing in a conventional approach, were traditional in the past. They are now less frequent as more spontaneous poses are preferred in normal situations. Experience of live art work with young children can provide you with a few tips to adopt to reduce a child's lively movements. For example, plan for a member of the family to be present (parents, older brother or sister); place the children in an environment known to them, while they are busy with an activity or game; respect the children's characters and attention span, not letting them grow bored or disturbed by external stimulus (such as excessive lighting, noise or pets); plan short, discreet drawing sittings, while working at a distance and always maintaining the same level of sight. Children busy watching television often position their bodies in interesting and unusual ways, while their faces lose the expressions suited for a good drawing or portrait.

Use of photography

A child's face always reveals intense and changing expressions which are, however, fleeting and unrepeatable. Their spontaneity cannot be portrayed in a drawing done from life, even if done quickly or stored in one's memory, but it can be captured in a photograph and this can then serve as a guide or reference document for a significant portrait. When working from a photograph, it is not necessary to copy it perfectly, but to try to capture some essential elements and integrate them with memories from observing the child directly.

Black and white photographs are more useful than colour ones in providing information about form and light and shade, which is necessary for a good drawing. For practical reasons, it is better to have photographs printed on paper rather than slides or photographs viewed on a television or computer screen; these procedures are useful, on the other hand, for practising drawing as they simulate the presence of a live model to some extent.

Digital photographs, which are now widely used, do not usually achieve the level of refinement that was the norm in the previous photographic era of film and zoom lenses, but have many advantages of their own for the artist:

photographs can be taken with small pieces of equipment that do not attract the model's attention and thus guarantee a 'fresh' picture; lots of photographs can be taken at a very low cost, and the chosen image can be blown up on a computer screen in order to analyse some details such as eyes, lips and the nose.

However, there is at least one aspect of photographic imagery that must be corrected when used as a source for a picture: the most common, cheapest camera lenses produce a certain degree of perspective deformation and 'flatten' shapes. This effect can be alleviated by photographing the model from a certain distance and possibly using a weak zoom lens, with an appropriate focal distance.

Lighting and *chiaroscuro*

The delicacy of the forms of a baby's face requires lighting to be diffused, simple and not too intense, and almost from a frontal or slightly oblique position. Natural light is better than artificial light, which must however be quite soft, as babies tend to squint and pull funny faces in reaction to the sun.

The shadows on their faces should not be too dark or large: the points where the shadows are denser are usually the corners of the lips or nostrils, but without the intensity of the darkness in the pupils or even irises.

Sometimes a rear or side source of lighting produces a good effect if it is additional and associated with the main front lighting: it is an expressive trick influenced by photography, and an aesthetic element applied to formal portraits, even for very young children, as long as the multiple light sources do not interfere with each other or cancel out the natural volume of the form.

Manner and expressions

Although they are an attractive artistic subject, small children are not easy models as they never stay still for the necessary time to draw them and they cannot be asked to pose. Extemporary sketches give good results, however, due to the immediacy and essentiality: for this reason, they should never be corrected or 'completed' afterwards. The task is perhaps easier with babies: using the times between their frequent feeding, when they are resting or asleep, it is possible to draw them relatively calmly.

A baby's gaze is efficient and attractive if directed at the observer, but usually attitudes, expressions or spontaneous, random glimpses that only photographs can capture and fully describe are more appealing, adding to the memory of having seen it directly.

What to observe and how to observe it

In the first two years of life (and, above all, in babies), it is very difficult to distinguish a boy from a girl by looking at the face only. Some hints of the typical different characteristics can be seen in the face regarding for example their height, or width of cheekbones and nose.

When portraying children, the artist must consider the construction, the shape of the head and the proportions of the face, rather than the actual anatomic structure that underlies these elements: the skull is always essential for defining the almost spherical bone shape of the whole head and the limits of the face, but muscles are still soft and deep and hidden by fat pads, so that they do not in any way influence the surface. All in all, when drawing children's faces it is better to be guided by human, aesthetic sensitivity than by rigid construction and anatomical directions.

When drawing, it is important to suggest the actual and apparent age of the child. Precise ratios of proportion between the main elements of the face like eyes, nose and chin, their correct position and the delicate play of light and shade, avoiding shadows and colours that are too intense, features that are too lively, tonal planes that are too clearly articulated, contribute in a decisive way.

The sequence for observing the model is reflected in the sequence of executive phases of the drawing, inspired by the face (see pages 17–21): 1) evaluate the overall shape and main proportions; 2) trace the vertical median line and the horizontal line (it indicates the level of the orbital arches: all the other facial elements are located below this line); 3) divide the face (the lower-half of the overall shape of the head) into four sections using equidistant horizontal lines of equal height, indicating the level on which our facial features are located (eyes, nostrils, lips, chin); 4) place the ear; 5) evaluate the volumetric, constructional structure and the tonal shades that reveal it; 6) create the light and shade, with slightly graduated tones – when tracing shadows and shaping forms (using a pencil, pen or brush) it is sometimes advisable to follow the curves of the forms, as well as suggest their volume with delicate, blended tones.

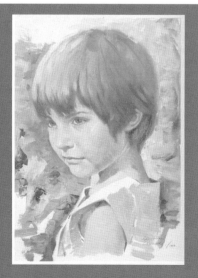
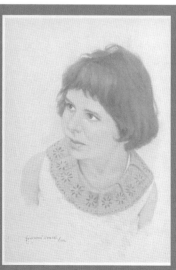

ANATOMICAL NOTIONS AND PROPORTIONS

In a baby, the skull bones have some spaces between each other that have not yet ossified, the fontanelles. These are spaces where the cranial sutures join, and are filled by cartilage. There are six main fontanelles: two medial, anterior and posterior; two anterior lateral and two posterior lateral. The skull is fairly plastic at birth and any deformations during labour are reversible in a short space of time.

The skull comprises two components: the braincase (or neurocranium, that contains the encephalus) and the facial skeleton. The full development of the skull is evidenced by the continuous changes in ratio between the volume and the height of the two parts as a person grows; for example, at birth, the ratio between the face and the braincase is about 1:8; at five years of age, 1:5; as an adult, 1:2. The disproportion is due to the greater, faster growth of the neurocranium after birth: approaching six years of age, it

is almost 90% of the size of that of an adult. Meanwhile, the cranium becomes more regularly curved, as the parietal prominences that are so accentuated in early infancy become much less pronounced. The facial skeleton remains small in proportion, however, as it is related to the development of oral and nasal cavities, the tongue, or the appearance of teeth. A baby's jawbone is very small and fine, comprising two separate halves that join together during the first year of life.

In children the face seems to be set back in relation to the front part of the braincase, but during puberty it is gradually pushed outwards by the development of the sensory organs contained within it, of the cranial base and the jaw. In the last years of childhood (about eleven to twelve years of age), faces develop more rapidly than the neurocranium, until they achieve the physical appearance of adulthood.

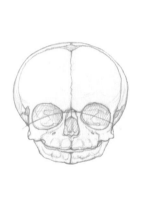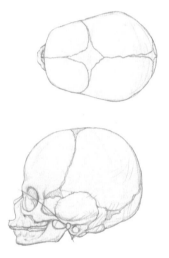

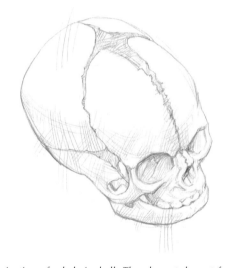

An infant's skull in a frontal, lateral and overhead projection. The curved line shows the conventional border between the facial skeleton and the braincase and highlights the difference in proportion, height and volume.

Oblique projection of a baby's skull. The clearest, largest fontanelle is the anterior medial one (bregmatic), that can be felt in the early months of a baby's life, underneath the skin.

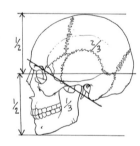

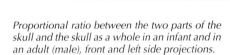

Proportional ratio between the two parts of the skull and the skull as a whole in an infant and in an adult (male), front and left side projections.

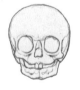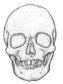

Conformation of the skull at various ages: nine months; nine to ten years; adult

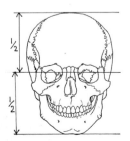

Proportions between the facial skeleton and the neurocranium in a male adult skull.

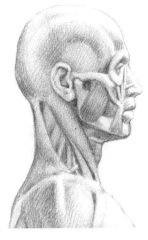

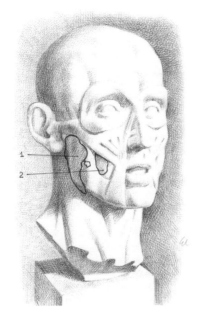

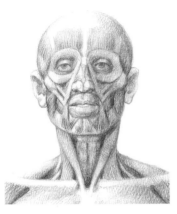

Diagrams of the muscular structure in the head and neck of an adult. It is obvious that the same muscles are found in an infant, although they are significantly less developed (especially in the masticatory components) and is largely hidden from view by the presence of adipose tissue under the skin, throughout the face and especially on the cheeks (buccal fat pad). Chubby, puffy cheeks, which are a characteristic of young children, seem to have various functions, for example, to attract parents' attention by arousing tenderness and affection or to promote the position of breastfeeding.

1 Parotid gland
2 Buccal (Bichat's) fat pad

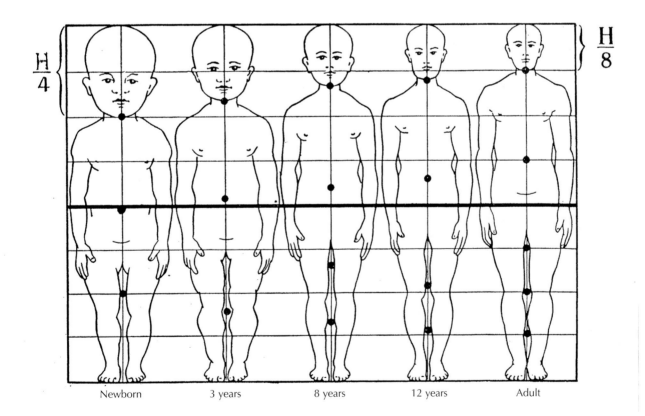

Newborn 3 years 8 years 12 years Adult

Diagram by H. Stratz showing the development and proportions of the body and head during various stages of growth. At birth, the height of the head corresponds to one quarter of the length of the entire body, while in an adult, it is about one-eighth of the height. The proportions of a baby's body grow and change rapidly, with phases of varying intensity, up to the beginning of adolescence (about fifteen to seventeen years of age), and then occur more slowly, confirming some differences between males and females.

The statistical survey suggests some metric sizes regarding the proportions of the body and head, which are also useful for the artist. For example: 1) Average height. At birth: approx. 50cm (19¾in); at one year, 74cm (29¼in); at three years, 92cm (36¼in); at six years, approx. 100–110cm (39½–43¼in). 2) Proportion of height. At birth, 4 'heads'; at one year, 4½ heads; at three years, 5 heads; at six years, 5½ heads. 3) Height of the head. At birth: approx. 11–12cm (4¼–4¾in); at one year, 16cm (6¼in); at three years, approx. 17cm (6¾in); at six years, approx. 18cm (7in).

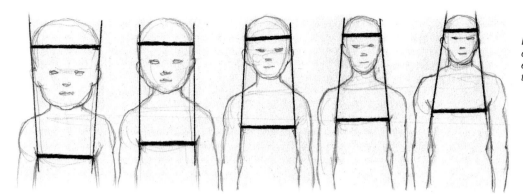

Diameter of the head in ratio to the diameter of the thorax during and at the end of growth: baby; thee years; eight years; twelve years; adult.

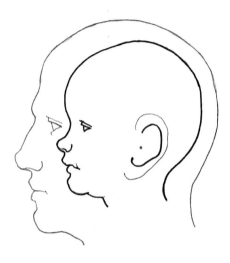

Comparison between the head's profile and volume in a young child (about two years old) and in an adult.

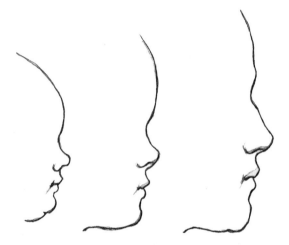

Line of the facial profile at different ages: early months; six years; twenty years.

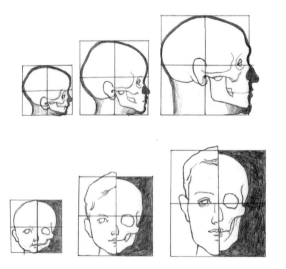

Ratios of proportion and thickness between the bone structure and the external forms (provided by 'soft tissue'). In an infant, the maximum length (frontal-occipital) of the head is about 11cm (4¼in). The maximum width (biparietal diameter) is about 9cm (3½in).

Infant; six years; adult.

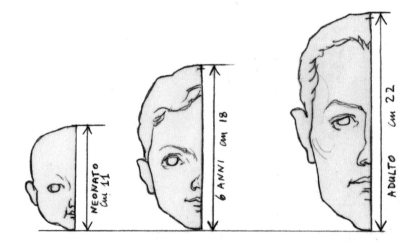

Average height of head at different ages: infant; six years; adult.

Proportions of the head and external forms

A child's face is not the miniature face of an adult: the proportions and characteristics are typical and are very different. When drawing a child's face (especially at an early age and up to adolescence), it is necessary to consider the elements, shapes and their ratios, both common and fundamental. Some can be depicted as the head (from the front and from the side) can be drawn within a square frame: the eyes and ears are located below or just inside the horizontal median line that divides the height of the head into two halves: the face is smaller than the head; the nape of the neck juts out and the neck is small, slim and short;

the outer ear seems larger than the other facial features; the bridge of the nose is concave while the tip points upwards; eyelashes are long while eyebrows are thin and sparse; the upper lip sticks out more than the lower lip; the chin is small and not a sharp shape; cheeks are full and rounded; and the iris is almost the same diameter as an adult's and is fully exposed, seeming large compared to the palpebral fissure. The following diagrams by A. Loomis show the average proportions of the head, from the front and in profile, that can be found in the early years.

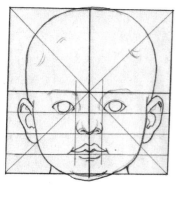
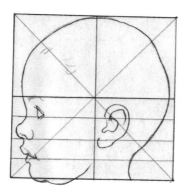

At approx. one year: the eyes and ears are below the horizontal median line; the jaw is short, low and rounded with a wide angle; the forehead is convex and jutting; the bridge of the nose is concave; the chin is small and cheeks are chubby; eyebrows are very thin, hair is fine and sparse; the nape of the neck is prominent and the neck is thin and short; the eyes appear large and wide apart.

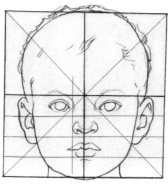
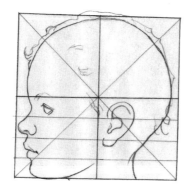

At approx. two to three years: the level of the eyes and ears rises a little towards the horizontal axis, but never reaches it, indicating a change in ratio between the volumes of the face and the neurocranium; the forehead is convex but less prominent; the upper and lower jawbones grow in size and length to make room for deciduous teeth; the nose is less concave; the upper lip juts out less and the chin is more defined; the hair is thicker and abundant.

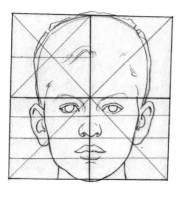
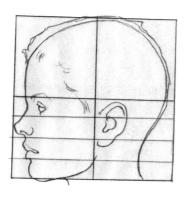

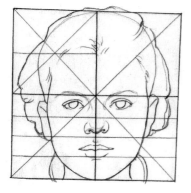
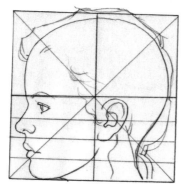

At approx. six to seven years: in the early years of life, it is rather difficult to distinguish the distinctive traits between males and females from only the face. Even the bone structure only has some aspects of dimorphism that then develop in adults, such as the angle of the jawbone, the shape and thickness of the orbital areas. The differentiation in facial features and proportions mainly occurs during puberty, but around six or seven years of age, some common characteristics can still be seen (as can easily be deduced in the two diagrams below): the facial/cranial ratio is reduced and the eyes and ears thus lie very close to the central horizontal line; orbits are close to adult size; the bridge of the nose is less rounded and longer; the forehead appears to be more vertical, as it is less convex; the chin becomes more prominent and the lower jaw is more developed; the lips and entire mouth area modify to make room for permanent teeth; hair is thick and the hairline is more evident.

MORPHOLOGY

In the early years of life, a child's head has at least a couple of fundamental, typical characteristics: the roundness of forms and the softness of physical features. Some morphological data has already been mentioned with regard to proportions on the previous page: they must be examined carefully and verified, wherever possible, in young models. Drawing eyes, nose, lips, etc. in their exact position and entered onto the right profile of the chin and forehead is much more important than a mere attention to detail in order to effectively render the child's likeness and age. Growing up, our faces become longer and are more similar to those of an adult, changing the proportions that are typical of all children in the early stages of growth.[1] Sometimes it may be wise to emphasise the forms of the face a little (but not the ratios, and without tending towards a caricature) in order to characterise age or expression in a better way. The jaw and chin are not developed much and the lower part of the face is therefore very low, creating a strong contrast with the width of the forehead, the fullness of the cheeks, the jutting out lips and the thin neck.

A child's skin is very thin and smooth, with a light covering of hair. A child's skin at birth will be paler than it will become in adulthood. Varying degrees of pigmentation gradually appear in the early months of life; many white-skinned children (Caucasoid), in particular those with blonde or red hair, often have small, slightly darker marks on their skin (freckles), which must be portrayed in the drawing with due caution and only very lightly.

Ratio between bone structure and external shape of the head (at approx. one year of age). The soft tissues, such as the muscles, subcutaneous layers and skin, form the layer (of varying thickness, depending on the regions) that cover the entire skull and provide the external shape to the head, giving the individual's physiognomic traits of the face. In a small child the layer is extremely thin in most of the head, due to the small size of the masticatory and mimicry muscles, but the layer is rather thick over the cheeks, owing to the presence of well-developed fat deposits called buccal fat pads (see page 7). Sometimes, surface veins can be seen through extremely fine skin especially on the forehead and temples.

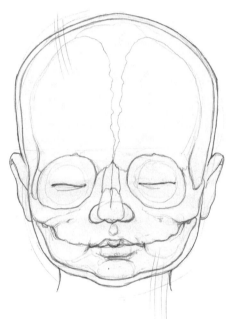

Direction of hair growth. At birth, hair can be sparse or thick, very fair or dark, but quite fine, soft and smooth. In later months, hair becomes stronger, thicker, longer and with a more defined colour. It grows from a central vortex placed at the top of the skull and extends in several directions, as shown in the diagram, usually from left to right. The hairline, so characteristic in adulthood, only develops gradually as a child on the forehead and temples.

[1] For more extensive and in-depth information you can refer to my previous book, *Heads and Faces* (Search Press, 2012).

Hair is a very important physical feature when sketching children's faces and expressions. Sometimes their hair is tidy, styled and cut according to what current fashion dictates (see page 59), or tied in plaits or ponytails, but it can often also be dishevelled by the wind and ruffled by play. The shape of hair can vary from smooth to wavy to frizzy. Natural colour also varies, from very fair (blonde) to very dark (black) or of an intermediate colour (such as chestnut brown or reddish). For each colour, lighting causes areas of shadow and reflections in the hair. When drawing a child's hair it is necessary to consider how soft it is, whether it is thick or fine, wavy, straight or curly, and its overall volume, which is subject to the effect of lighting. In fact, hair must not be drawn as individual strands using a number of lines, but drawn to represent the main mass of hair: a few odd, thin lines are enough to hint at lighter sections, or the way it is arranged and in which direction. After identifying the 'local tone', that is, the predominant colour of the child's hair, draw in the darkest areas first, adding then the mid-tone areas, and finally the lighter, reflected areas. Of course, it would be possible to sketch this sequence in reverse, but the result would be less effective. Building tones in order of intensity is enough to suggest the lighter or darker colours present in a child's hair.

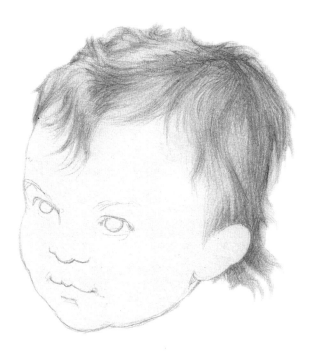

Light-coloured hair

Dark-coloured hair

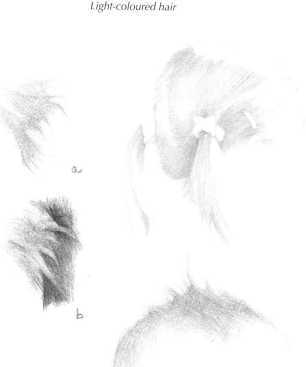

Parents of very young children (but only while they remain young …) enjoy choosing fun, unusual hairstyles for them, which are sometimes traditional or extremely ingenious. Plaits, for example, are common in older girls: they are interesting to draw for their complexity, with intertwining locks of hair and the shapes of the ribbons or bands that tie them. One useful trick to suggest softness is to provide contrast to the outline of the hair by making it less defined in a some areas, with a few stray hairs standing out on a dark background (b) or vice versa (a).

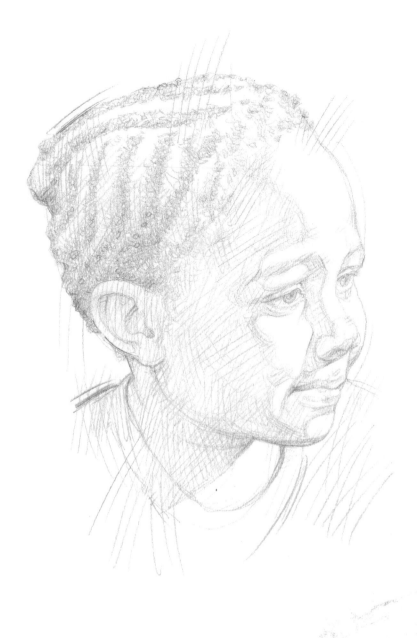

Hair is an important element in drawing young children's heads, not only in its external shape (it may be smooth, wavy, frizzy, etc.) or colour (blonde, red, brown, black, etc.), but also in the style in which it is shaped (by adults), following a fashion or an extemporary aesthetic taste.

It is fun to see how children's faces become even sweeter by the way in which their hair is styled and cut. I captured a few examples here.

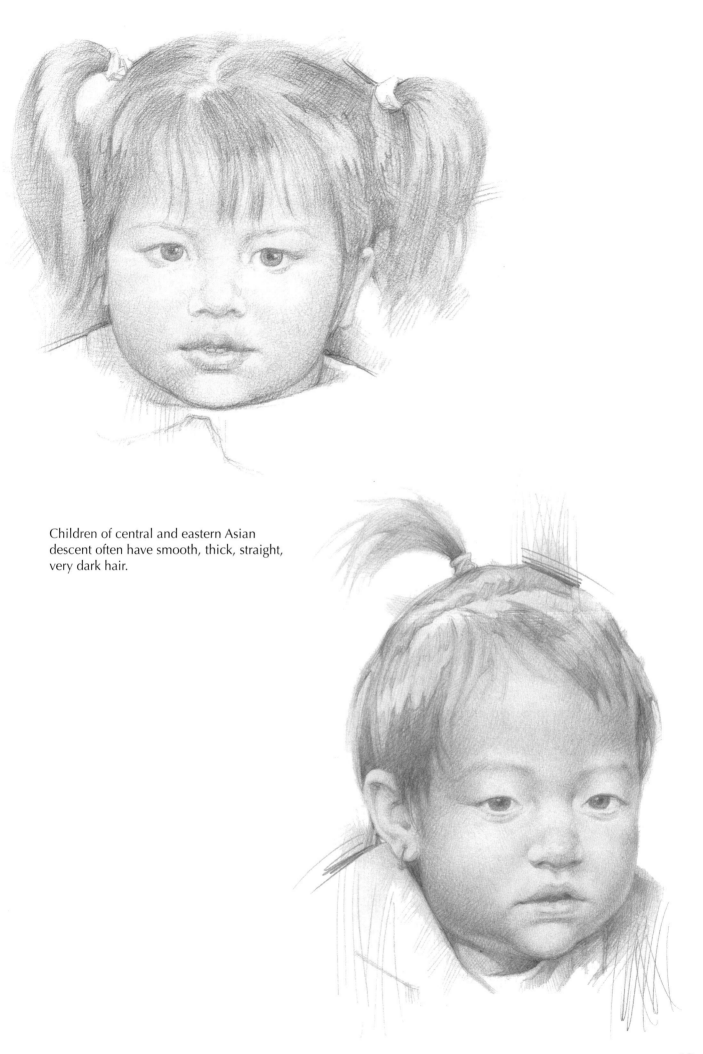

Children of central and eastern Asian
descent often have smooth, thick, straight,
very dark hair.

The outer ear. The structure of the outer ear is almost entirely formed by cartilage except for the lower part, the lobe, which is flesh. The cartilage, covered by very thin skin, is rather flexible and has a typical, concentric formation (the outer edge, the helix, surrounds a cavity, the concha, which is in turn encircled by the anti-helix), but also varies in shape for each person. In children, the outer ear is very similar in aspect to that of an adult but is more rounded, with an axis slightly tilted backwards and jutting out to varying degrees. Especially in the early months of life, the ear appears larger than other elements of the face and in relation to the head itself. Anthropometric measurements have been taken of the average ear length, which may prove usefui to the artist (for example: at one year, 47mm (1¾in); at three years, 50mm (2in); at 6 years, 55mm (2¼in); in adulthood, about 62mm (2½in)). In accordance with the smaller scale of the skull, the ear is in a lower position on the skull, corresponding to the outer ear canal on the temporal bone, next to the mandible joint. Drawing the outer ear must be accurate but not detailed excessively, as it is a feature of lesser importance when compared with the eyes and lips – two characteristics to which one should give the most attention.

The nose. The anatomical structure of the nose is partly bone (at the root or 'bridge') and partly cartilage (the septum, the tip, around the nostrils): this latter portion, which is softer and flexible, reacts to the movements in the facial muscles. In very small children, however, the nasal bones and cartilage are not yet developed: the bridge is not sharp and is close to the plane of the face; the nose is concave and the tip aimed upwards, making it seem short. The concave bridge is accentuated by the convexity of the forehead, which forms a very characteristic form in early years, in both genders and various ethnicities. During childhood and adolescence, as a result of the growth of the facial skeleton, the nose becomes longer, more defined at the bridge and wider at the nostrils. When drawing the nose (in a face of any age, but especially in children), it is advisable not to place too much emphasis on light and shade: it is sufficient to indicate its position exactly, together with volume and delicately suggest (i.e. without clear lines or intense shading) the rounded, soft forms of the tip and nostrils.

The eyes. In the early months of life, visual perception develops gradually; the capacity to use the two eyes at the same time, based on full coordination of the eyeball muscles develops at about three months and is complete at around one year of age. At birth, the eyeball is not yet at full size but, in ratio, the iris and cornea already have a diameter that is close to that of an adult. (approx. 12–13mm (½in). This makes a child's eyes look very large and noticeable, an effec accentuated even more so because the iris is emphasised

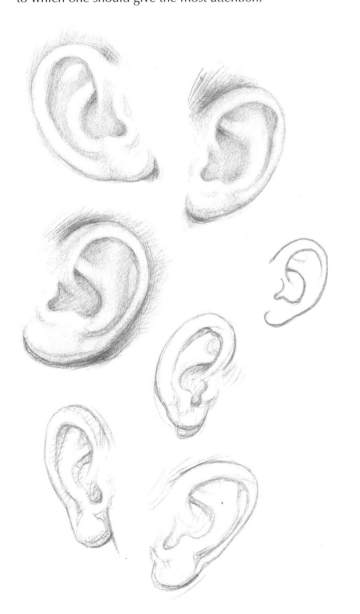

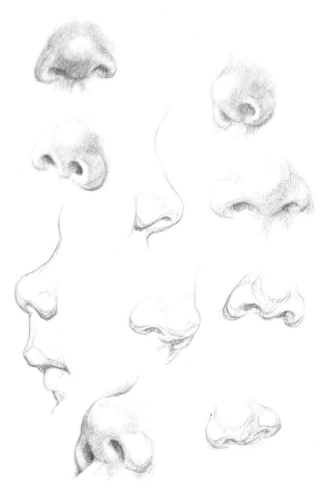

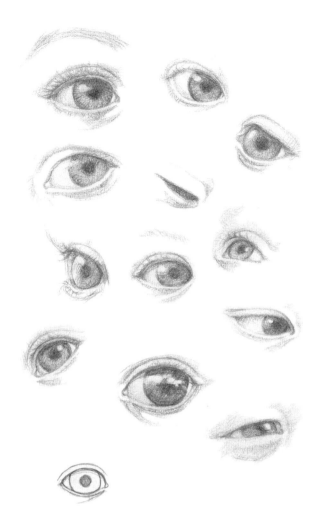

allow you to see the tongue or teeth – primary or permanent – depending on number and position (for example: towards eight months the two lower central incisors appear; at one year, the four upper incisors appear; at about eighteen months, the other two lower incisors; at around two years, canines and remaining teeth). In very small children, the two lips are especially soft and delicate, and are different in shape to one other: the upper lip is bigger in volume and juts outwards – especially in the centre – more than the lower lip, which is less defined and sometimes only outlined by the shadow formed in the groove below it. As children's cheeks are full and rounded, the corners (junctions) of the mouth are distinct and deep, while the small chin recedes into the face in comparison with the lips. If seen from the front, they have an almost triangular shape, but it is possible to distinguish lines and depressions on each lip, which are much more distinctive on the upper one (there are three: a central relief and two flatter parts to the side) and more blurred on the lower one (where there are two weakly convex areas separated by a central, light depression). These grooves flatten when spread into a smile, or are accentuated when the mouth puckers up when sulking. The infant often keeps his lips open so they are almost always wetted with saliva, and for this reason often seem shiny and reflective.

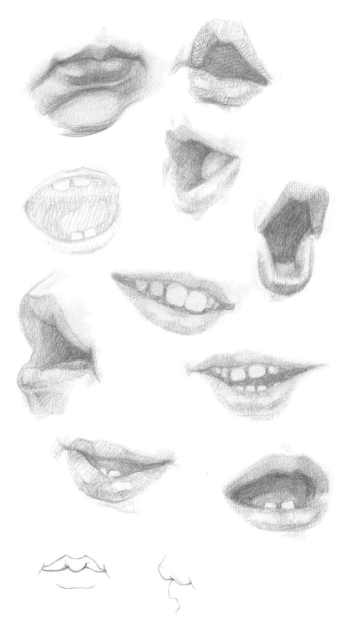

by the small palpebral fissure and the reduced size of the face. When a child's eyes are fully open, the upper eyelid is barely visible, while the inner joining of the lids contain the small pink formation called the caruncle. At birth, irises are almost always a pale colour (blue-grey or blue) as they do not contain the final pigment. In early months, the sclerotic coat (the white part of the eye that can only be seen in small parts at the side of the iris) is greyish in colour, influenced by the dark tone of the underlying retina. A newborn baby's eyes protrude a little compared to the orbital plane and are further apart than they will be at a later date (see page 9). The exact position of the eyes in a drawing of a child's face is very important, as the level of proportion (see page 9) is characteristic: varying in relation to the different phases of growth, it alone clearly indicates the child's or adolescent's age. The eyelids are thin, fringed with long lashes. Eyebrows are sparse and thin, especially in early years of life: they gradually become thicker, darker and more arched. Children of central and east Asian decent also have a characteristic shape of their upper lid that describes an almond-shaped eye. This fold is in the skin and extends from the root of the nose and covers the upper lid and inner corner of the eye. In young children, this fold can sometimes be accentuated as a vertical flap (epicanthic fold) that covers the medial angle of the eye and the lacrimal caruncle: it is usually a temporary shape, which diminishes in later years.

The lips. Lips are commonly identified by the two rosy edges that join at the oral cavity and that cover the dental arches, following the latter's curved surface. They are extremely flexible and expressive and, depending on a child's age,

DRAWING PROCEDURES

When drawing children's faces, do not obsess over the details too much: it is much more important and effective to capture the child's attitude and expression, and also facial proportions, form and lighting. These elements alone are sufficient for achieving an authentic and faithful likeness of a 'portrait'. In this book (and in all the books appearing in this same series), I have preferred to adopt and suggest, at least to those who are at the very beginning of a path of study, a way of proceeding by paying attention to the 'real forms' – in other words, a more descriptive style.

This path, which has been well-practised by traditional schools of good academies, does not immediately approach a strictly artistic expression, but is able to promote it by placing solid foundations through technical and perceptive skill. Familiarity with drawing tools, the way in which they are used and knowing 'how to see' through the use of classical 'intellectual tools' (perspective, anatomy, composition, image processing and so on) inevitably transform painting a simple portrait into an activity allowing full freedom of artistic expression.

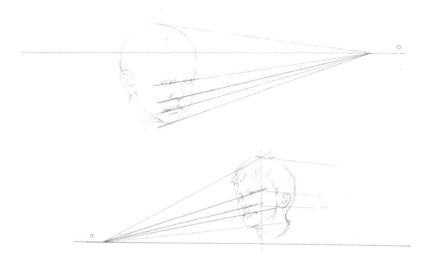

Perspective is a drawing method used to represent depth and spacial relationships on a two-dimensional surface. Therefore the head, in order to be correctly portrayed, must be drawn so as to take the principles of oblique line perspective into consideration.[1] The head can be imagined as if it were placed in a cube, where the edges will touch the areas of the face that jut out most. In this way, it becomes easier to put the main physical features 'into perspective' with some approximation, helping to gauge the right levels and distance between features, and ensure they are consistent with the curved surface on which they lie. A child's head is very small, but rules of perspective are still applicable – although the result is less visible than that on an adult's head, which is wider, more sharply outlined and with a solid structure.

To increase or reduce the area of an image, photograph, or a sheet of paper, draw a diagonal line and choose the new size.

To translate an image faithfully and easily, when increasing or reducing the size, it is sometimes helpful to use a square 'grid' (a set of horizontal and vertical lines in any case) drawn lightly on the reference image (photograph, drawing or even in one's surroundings) and on the sheet being drawn on. In order to avoid damaging the image that is being altered, do it on a photocopy of the image or overlay it with tracing paper. Creating the grid must be intuitive: the interval between the horizontal and vertical lines is usually constant and chosen according to the enlargement measurements and the degree of precision with which you wish to transfer the reference image details.

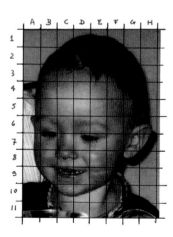
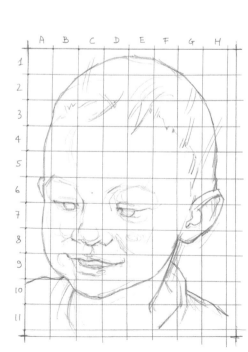

[1] Oblique linear perspective involves two vanishing points on the horizon meeting the parallel lines projecting diagonally from a stationary object. For more information a previous book in this series may be consulted, *Understanding Perspective* (Search Press, 2012).

Traditional methods: generic sequences to be followed

There are several ways to proceed in drawing, here in particular the face, depending on each artist's preference and needs. At the start, it is wise to experiment and compare in order to decide which technique suits your style and abilty. This page shows the most simple, intuitive and 'scholastic' method; on the next page are another two linear diagrams, similar in result, but rather different in the way of conceiving and perceiving the image. For example, **Method A** is deductive, starting from general to detail, and views the head as an overall volume on which details of the face are then introduced; **Method B** (inductive, from detail to general) is based on the choice of a significant physiognomic trait (eye, nose, etc.) from which one then proceeds, determining its ratio between it and other features, and coordinating them so as to gradually build the overall shape.

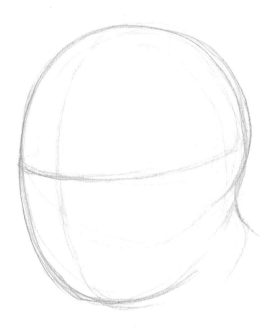

Step 1 *Outline of the overall shape of the head, its chosen dimensions ('bulk'), the level of the eyebrows (curved line) and the median line of the face.*

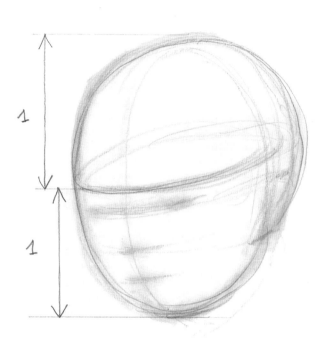

Step 2 *The levels on which the eyes, nose, lips and ears sit are defined.*

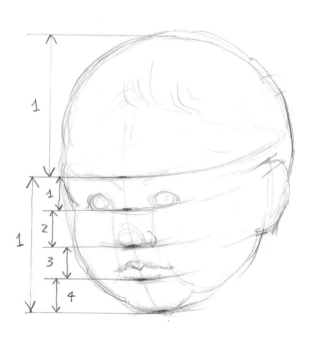

Step 3 *Definition of proportions and distances between the levels of facial elements.*

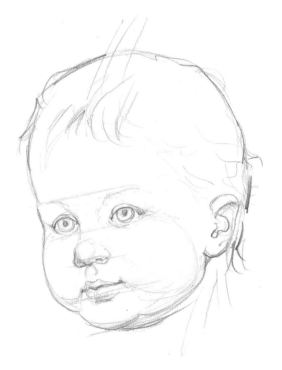

Step 4 *Elaboration of the forms and light and shade.*

Method A (described on the previous page)

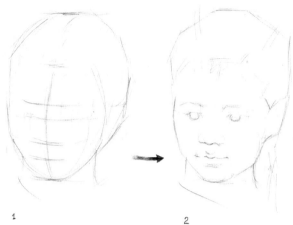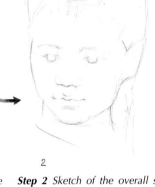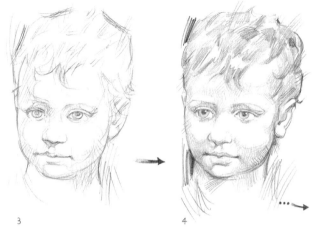

| 1 | 2 | 3 | 4 |

Step 1 *Outline of the overall shape of the head, its chosen dimensions ('bulk'), the level of the eyebrows (curved line) and the median line of the face.*

Step 2 *Sketch of the overall shape of the head, its chosen dimensions ('bulk'), the level of the eyebrows (curved line) and the median line of the face.*

Step 3 *Shapes and elements of the face defined through simple line drawing.*

Step 4 *Elaboration of tones.*

Method B

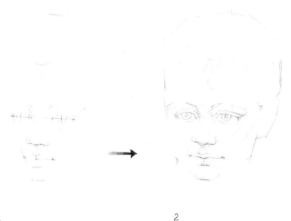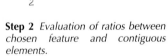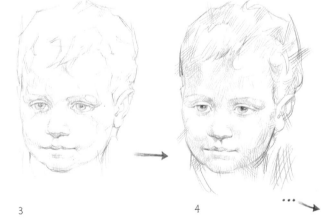

| 1 | 2 | 3 | 4 |

Step 1 *Choice of a facial feature and construction of the facial triangle (eyes, nose, lips).*

Step 2 *Evaluation of ratios between chosen feature and contiguous elements.*

Step 3 *Definition of the whole head through simple lines.*

Step 4 *Elaboration of the forms and tones.*

Another, more 'painterly' way of drawing places less emphasis on the linear style (at least on a conceptual level) and favours the 'tonal' one: more importance is given to light and shade produced and appearing on the head – known as 'mass drawing' – than to its structural lines. From the early stages drawing, tone and lighting – or chiaroscuro – take precedence over the outlines of the face, and the volume of the whole head, or of each physiognomic trait, emerges from the contrast and accordance of tones. Using suitable tools (charcoal, ink wash, soft graphite, etc.) you can experiment with this method as you practise the more linear style (following both a deductive and an inductive path), as the correctness of proportions and the right positioning of features are essential in any method adopted, especially when drawing very young children.

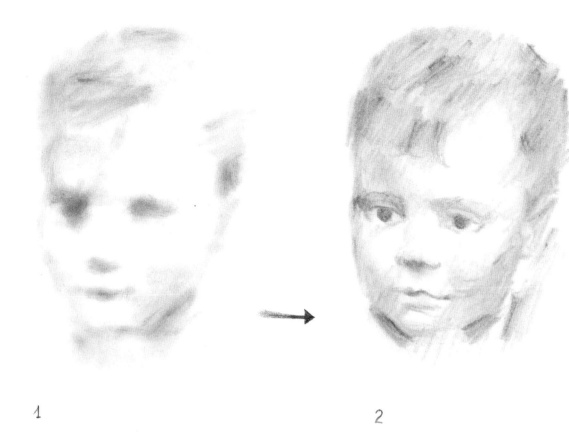

1

2

3

Step 1 *Indication of the darker tonal areas, enough to suggest the position and size of the physiognomic traits and the volume of the head.*

Step 2 *Definition of the initial tones and introduction of intermediate tones (the white of the paper represents the tone of the most highlighted areas).*

Step 3 *Elaboration of tonal values and introduction of small details, accents of shade and light, and so on.*

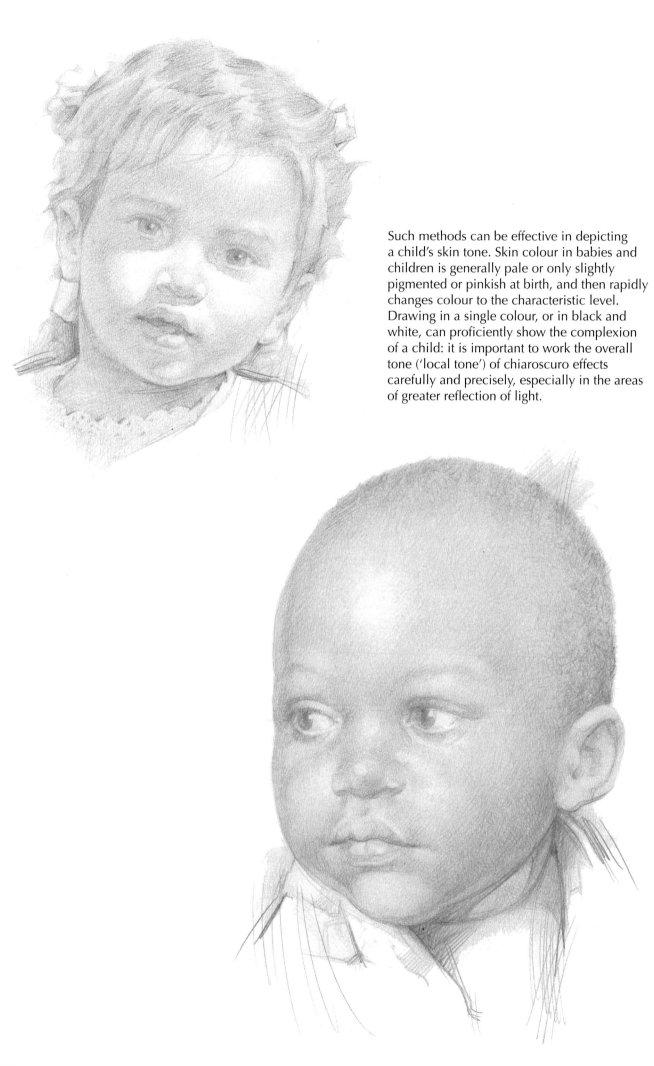

Such methods can be effective in depicting a child's skin tone. Skin colour in babies and children is generally pale or only slightly pigmented or pinkish at birth, and then rapidly changes colour to the characteristic level. Drawing in a single colour, or in black and white, can proficiently show the complexion of a child: it is important to work the overall tone ('local tone') of chiaroscuro effects carefully and precisely, especially in the areas of greater reflection of light.

Little ones are fascinating to observe and sketch. It is not always easy to portray children in a busy environment, however, either through drawing or photography: it is often wise to just observe them from a distance, attempt a few quick sketches and capture a few aspects of their features and expressions.

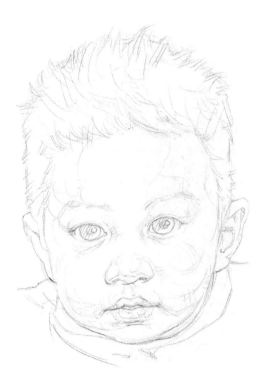

Step 1

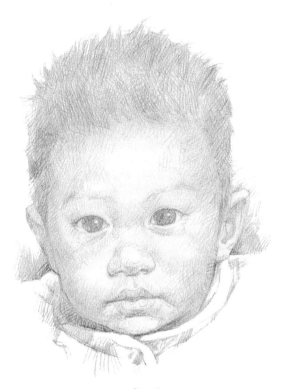

Step 2

Step 1 – *The overall shape of the head has been hinted at with a light stroke of graphite, placing it in relation with the edges and proportions of the individual parts.*

Step 2 – *Gradual modulation of light and shade, beginning with the light tones and then proceeding with the more intense shade and accents on the darker tones.*

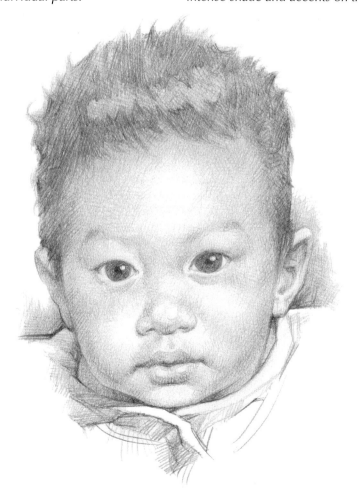

GRAPHIC TECHNIQUES

The faces of babies and young children have delicate, rounded features that blend into each other harmoniously. It is therefore an important decision to use a graphic technique and expressive style to portray them that is suited to rendering these characteristics effectively. The baby's delicate forms tempt one towards an accurate, softly blended drawing, but this is a tendency that should be controlled carefully, to avoid an inconsistent and simpering portrayal. Although it may be difficult to capture the articulation of tonal 'planes' on a baby's face, and it is advisable to reduce the intensity and size of shades, it is wise however to adopt a style that combines a mixture of forms with a moderate vigour in drawing. Some of the most commonly used graphic techniques in childhood portraiture are mentioned in this section (up to page 25): a comparison between the characteristics peculiar to each of them and an examination of the relative results of expression will help you to choose the one most in keeping with your temperament and style, and to the features of the small model.[1]

Dry brush

This technique involves the application of ink using a semi-dry brush: when placed on absorbent paper, the bristles spread out and then trace thin parallel lines of a light intensity. The effects differ depending on whether the drawing is on smooth or rough paper. The mid and dark tones are obtained by overlapping strokes, similar to drawing with a pen or pencil. In place of India ink, any other diluted pigment can be used (watercolour, gouache and oil) and then spread using a fairly dry brush.

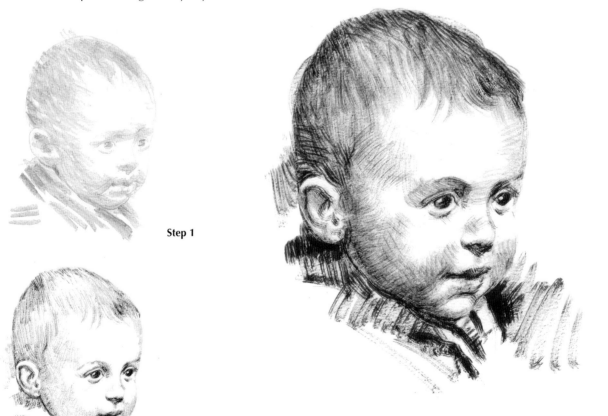

Step 1

Step 2

[1] The techniques presented here are well known and so are only mentioned briefly. The main characteristics and properties of each are written about in other books in this series: *Drawing Techniques* (Search Press, 2002); *Heads and Faces* (Search Press, 2012).

Pen and ink

Pen and ink can be used to create very small drawings, also in relation to the thickness of the nib or other similar tools (such as s felt-tip pen, ball-point pen and bamboo). The lines that are closer or wider apart, and crossed over each other with varying intensity, depicting the main tones (beginning from the lighter ones and proceeding with the varying intensity of chiaroscuro) must be applied confidently, but also lightly and with caution in order to reproduce the delicate forms and convexity of the child's face. Sometimes very fine lines can be achieved by placing the back of the pen nib on the paper. A drawing is normally traced first with a pencil (perhaps an outline that can easily be erased at the end of the work, when the ink is fully dry) to plan the direction of the lines, how thick they become, and to be sure the proportions are correct. If, however, the drawing is done directly in pen with no initial pencil sketch (opposite), a more immediate, spontaneous effect is achieved that is lively and expressive; on the other hand it also introduces some difficulties – technical (lines cannot be erased, there is a risk of ink marks) and psychological (fear of making a mistake, uncertainty in defining proportions, etc.) – though all can be overcome by hard, continuous practice.

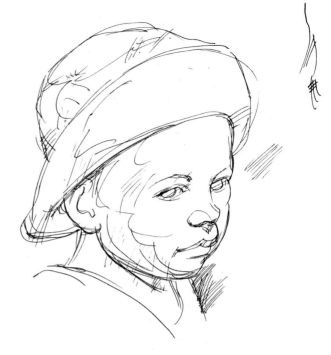

Drawing with no preparation, directly using pen.

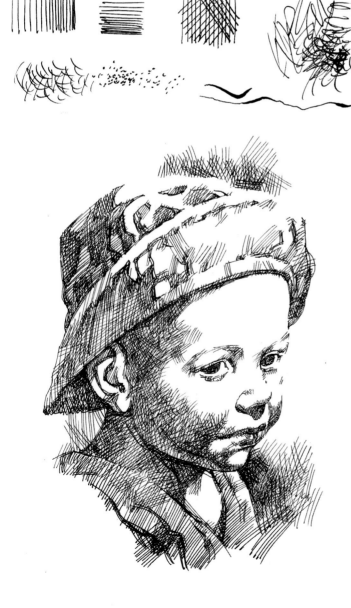

Step 1 *Pencil guide drawing*

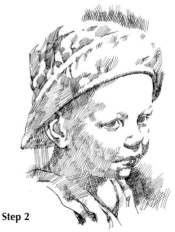

Step 2

Charcoal and sanguine

Charcoal (carbonised wood or compressed dust) is very ductile and allows you to get very nuanced shades of grey or deep black. Sanguine has similar properties, but with brown or reddish colours. The gradations of the colours, as with all 'dry' techniques (pastels, chalks, etc.) are attained by blending the intense lines with the finger (or a cloth, brush, or blending stump) or by 'lightening' them using a soft rubber. Charcoal is not very stable and is dusty by nature, and it is therefore better to reduce any flaking in the finished drawing by fixing it with a specific protective liquid.

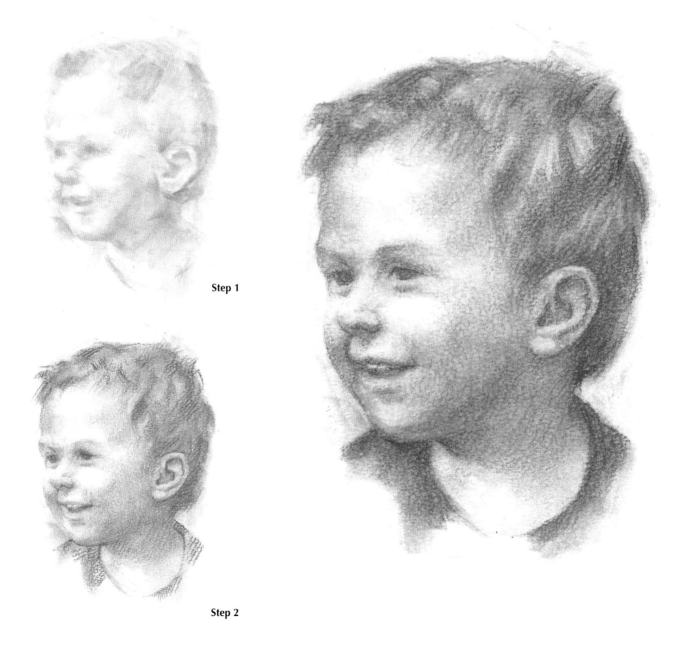

Step 1

Step 2

Soft graphite

Graphite is one of the most simple, versatile tools available to artists for any kind of drawing and for any expressive style. Graphite is made in various degrees of hardness and is available in cylindrical shapes of varying diameter, from the thinnest (pencil, propelling pencil, etc.) to the thicker variety, that can be held without the need for any support, and which are usually in softer grades (such as 6B and 9B). Soft graphite allows you to draw wide, dark lines that can easily be blended using the fingers. Unlike medium and hard graphite (HB, H, etc.), that are suited to small, clear, detailed drawings, the softer 'greasy' ones are more suited to drawings that are less rich in detail, but much larger, spontaneous and vigorous, while keeping the subtly changing shapes of children's faces. The best effects with soft graphite are attained on rough paper, where lines spread and become more blurred.

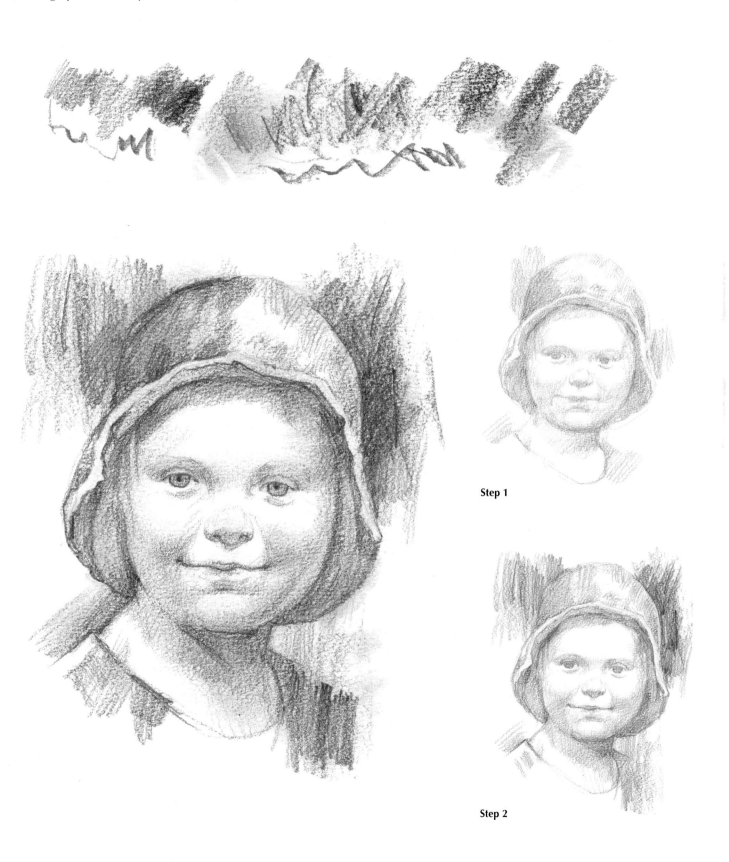

Step 1

Step 2

A GALLERY OF FACES

In this large section (up to page 59), I am going to show you a range of study drawings of children's faces, of varying age, gender and expressions. They were all created with graphite on paper[1]: 'black and white', so typical of most graphic techniques, is also an intitial and aesthetic choice as it adds intensity and effectiveness to shapes. My intention is for these drawings to stimulate the habit of drawing from observation, and suggests how to proceed and analyse the model. This is why I have adopted here a realistic, descriptive style, but certainly (as it is only one possible starting point) each artist needs to develop their own distinctive style.

I have already mentioned (see page 4) the difficulties in getting children to 'pose' (younger ones may move around constantly, while older children pull unsuitable expressions): almost all the drawings shown here come from a very quick, preliminary sketch taken from a live model, and a number of documentation photographs taken almost at random and 'by surprise'. These indeed are essential for providing greater consistency to the detailed study and, in my case, to succeed in slightly, but consistently, altering the facial features a little in order to reduce the actual likeness with respect to the principles of confidentiality.

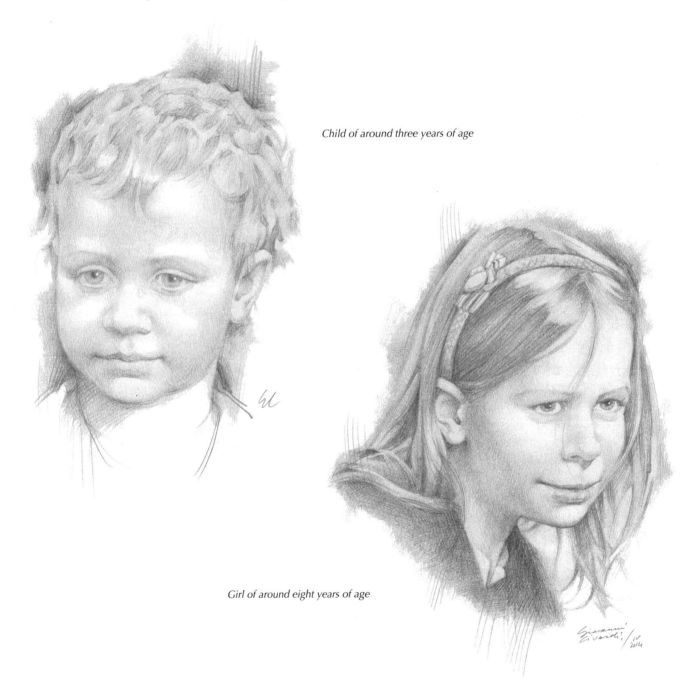

Child of around three years of age

Girl of around eight years of age

[1] HB and B graphite on notebooks 21.6 x 27.9cm (8½ x 11in) in size (Canson paper, 100gsm).

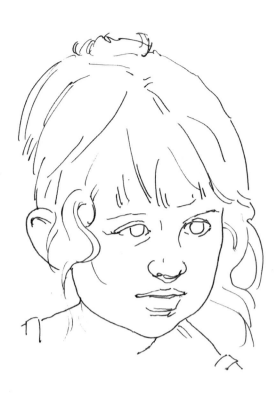

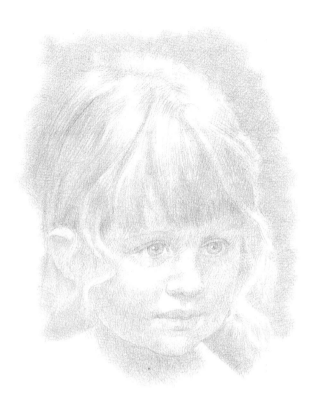

Ritratto

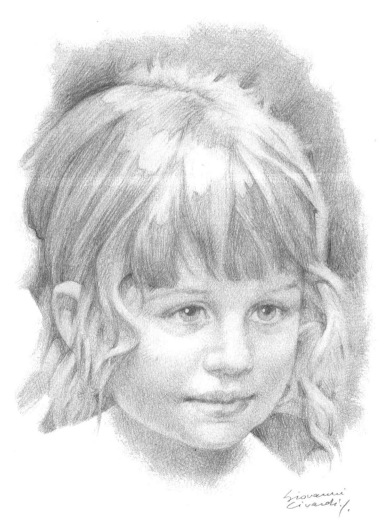

Child of around three years of age

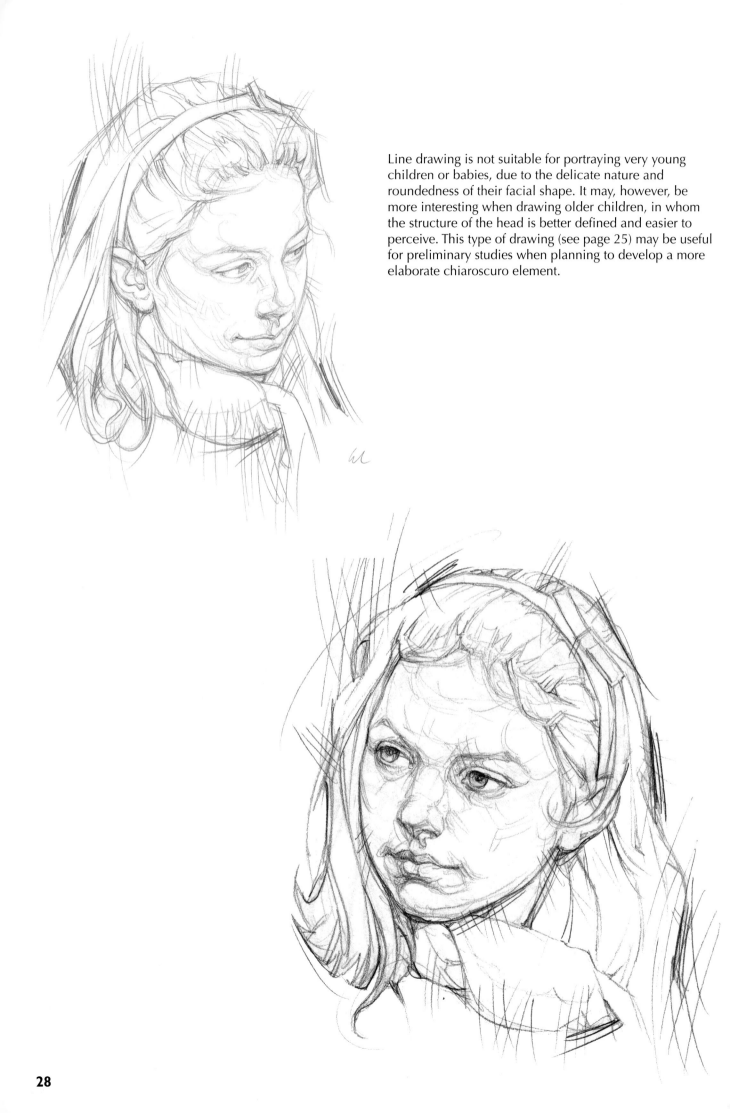

Line drawing is not suitable for portraying very young children or babies, due to the delicate nature and roundedness of their facial shape. It may, however, be more interesting when drawing older children, in whom the structure of the head is better defined and easier to perceive. This type of drawing (see page 25) may be useful for preliminary studies when planning to develop a more elaborate chiaroscuro element.

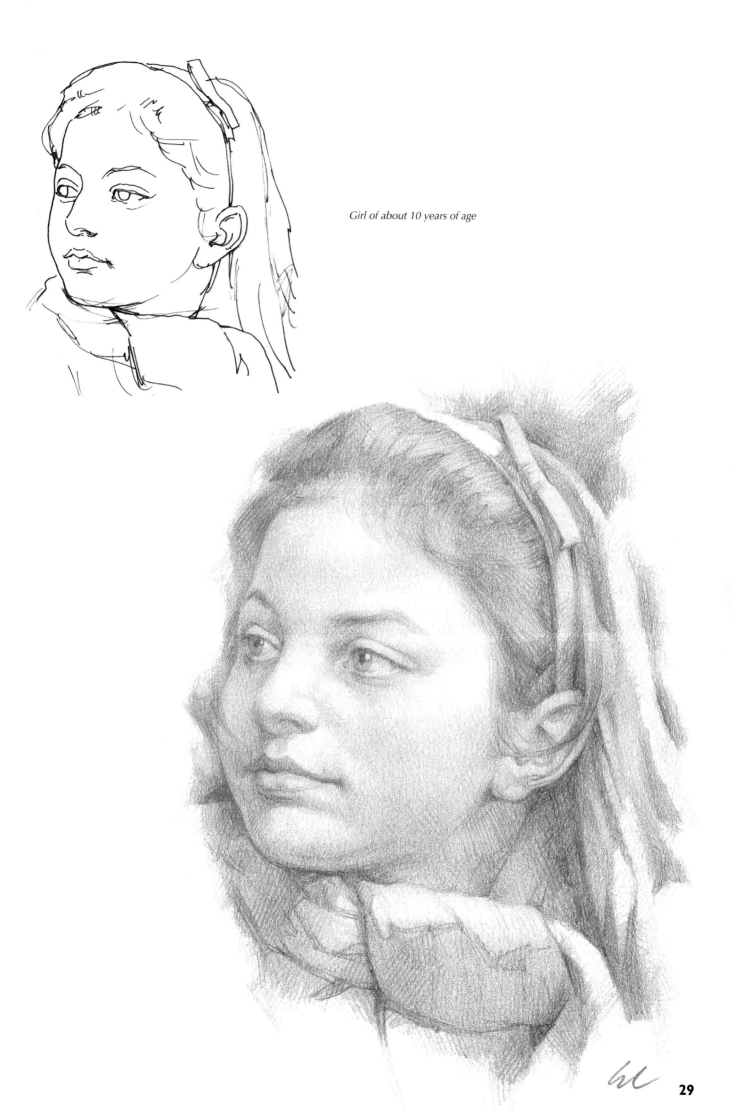

Girl of about 10 years of age

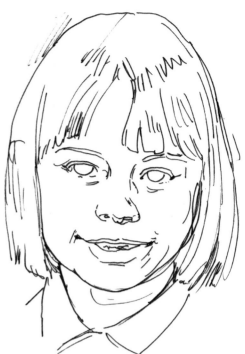

Girl of about six years of age

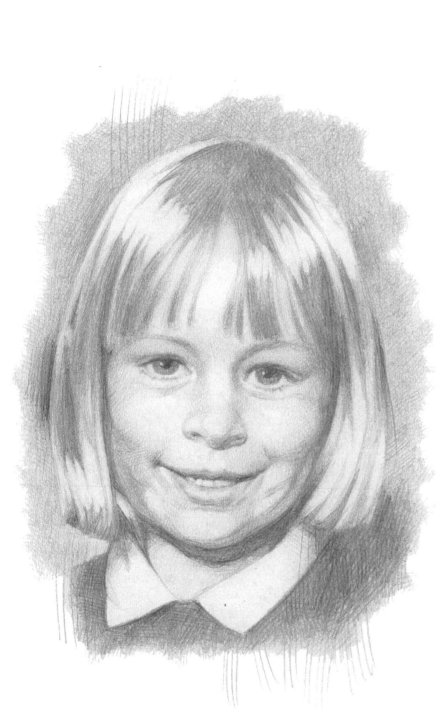

Alongside many of the portraits that appear on the pages in this section, I have also chosen to show the outline of the relative head, drawn directly in pen, in order to have an immediate idea of the compositional effect and the set of physiognomic traits. I have only depicted some essential elements in these quick, schematic drawings, just enough to characterise a child's expression and attitude, and the head's proportions and structure. If seen as an initial exercise of observation, my intention with this type of schema may serve as an initial sketch for a drawing to be embellished with a more complex technique; or for a painting – just enlarge the sketch using the grid technique (see page 16) or make a photocopy of a suitable size.

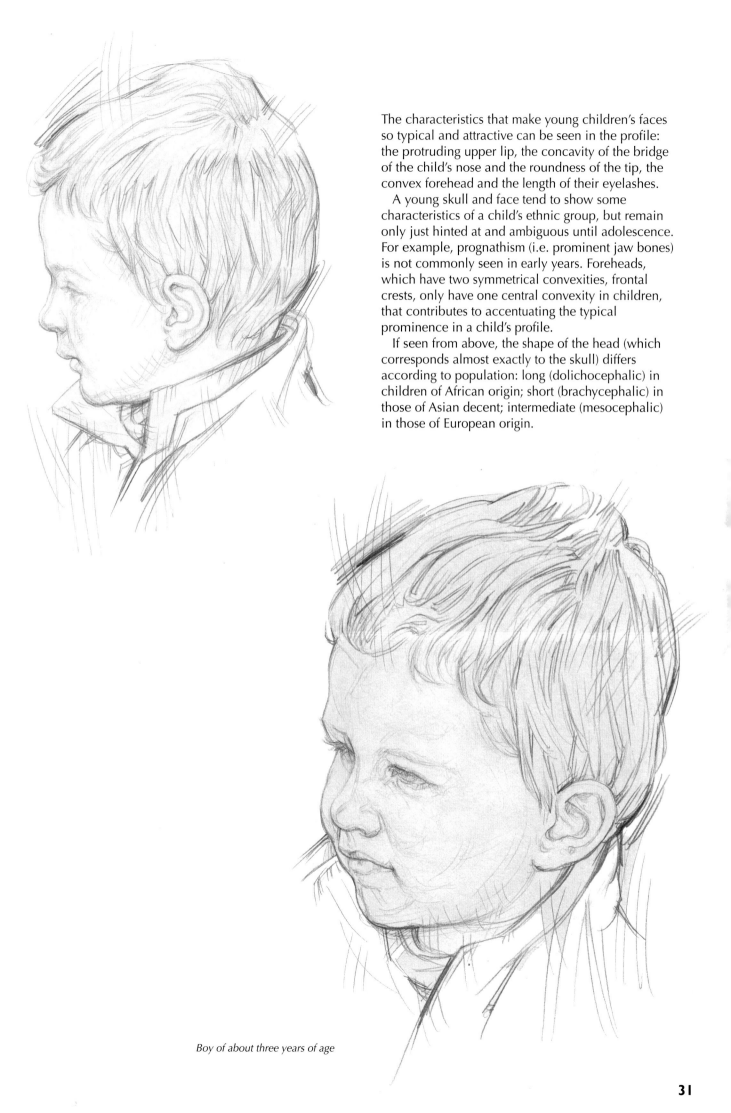

The characteristics that make young children's faces so typical and attractive can be seen in the profile: the protruding upper lip, the concavity of the bridge of the child's nose and the roundness of the tip, the convex forehead and the length of their eyelashes.

A young skull and face tend to show some characteristics of a child's ethnic group, but remain only just hinted at and ambiguous until adolescence. For example, prognathism (i.e. prominent jaw bones) is not commonly seen in early years. Foreheads, which have two symmetrical convexities, frontal crests, only have one central convexity in children, that contributes to accentuating the typical prominence in a child's profile.

If seen from above, the shape of the head (which corresponds almost exactly to the skull) differs according to population: long (dolichocephalic) in children of African origin; short (brachycephalic) in those of Asian decent; intermediate (mesocephalic) in those of European origin.

Boy of about three years of age

31

Up until three or four months of age, a baby's neck is weak
and is not able to fully support its head, which is very large
in relation to the rest of its body. Up until about the age of
two, a child's neck remains very short, with fine circular folds
around it that make it look as if the head has been 'rested' on
the child's shoulders. In later years of childhood, the neck is
still delicate and thin, although it gradually becomes longer.

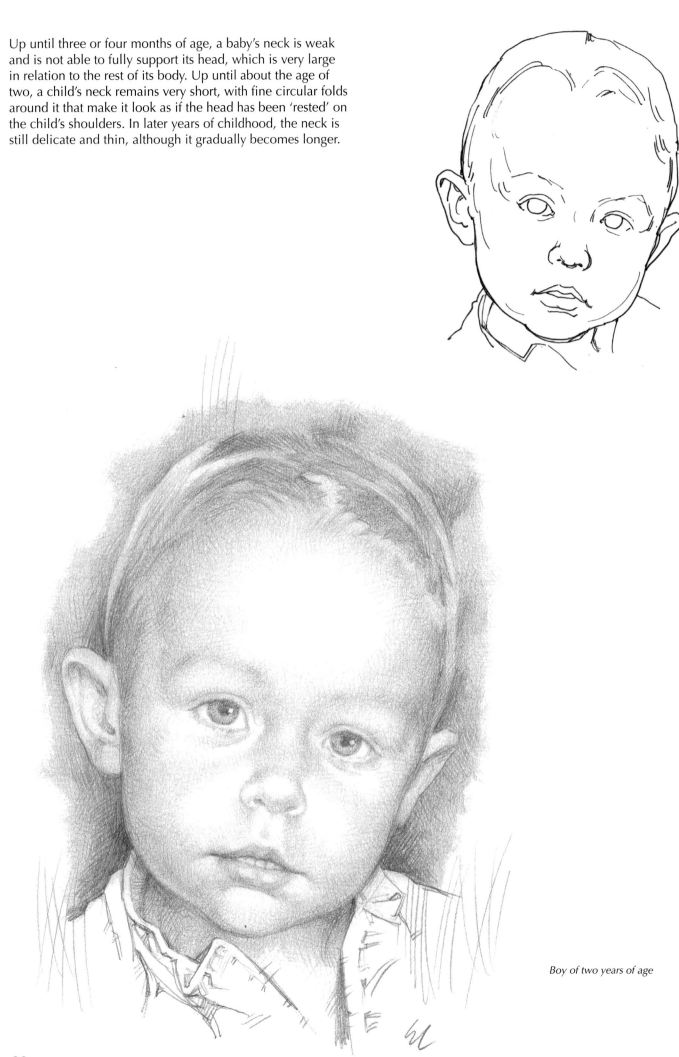

Boy of two years of age

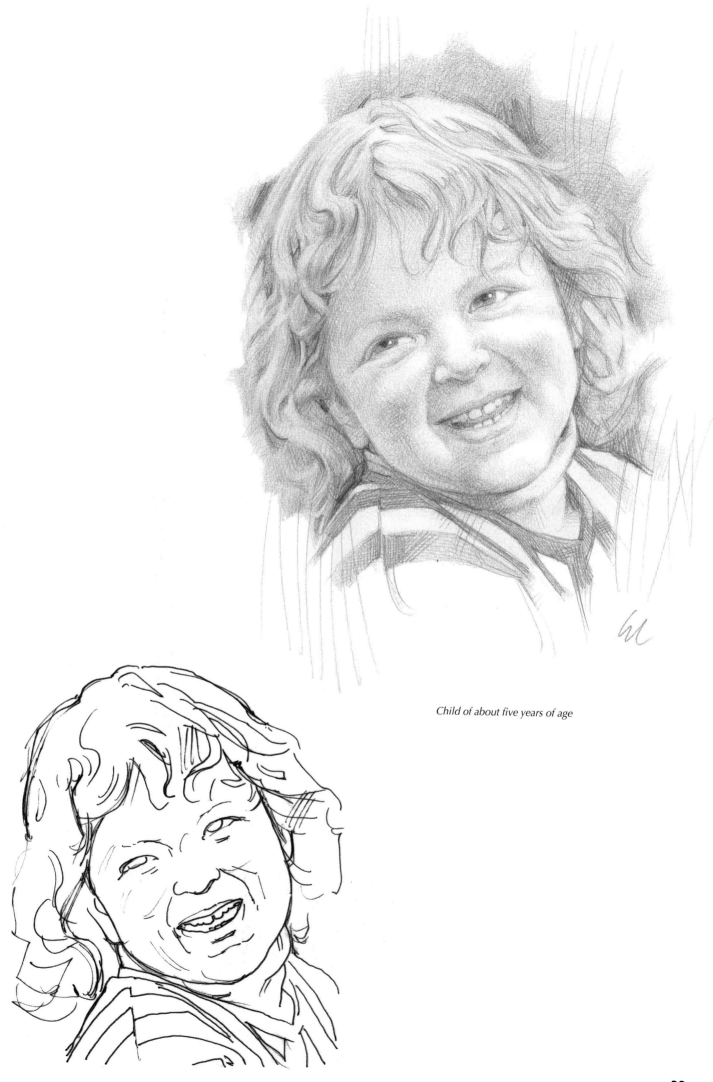

Child of about five years of age

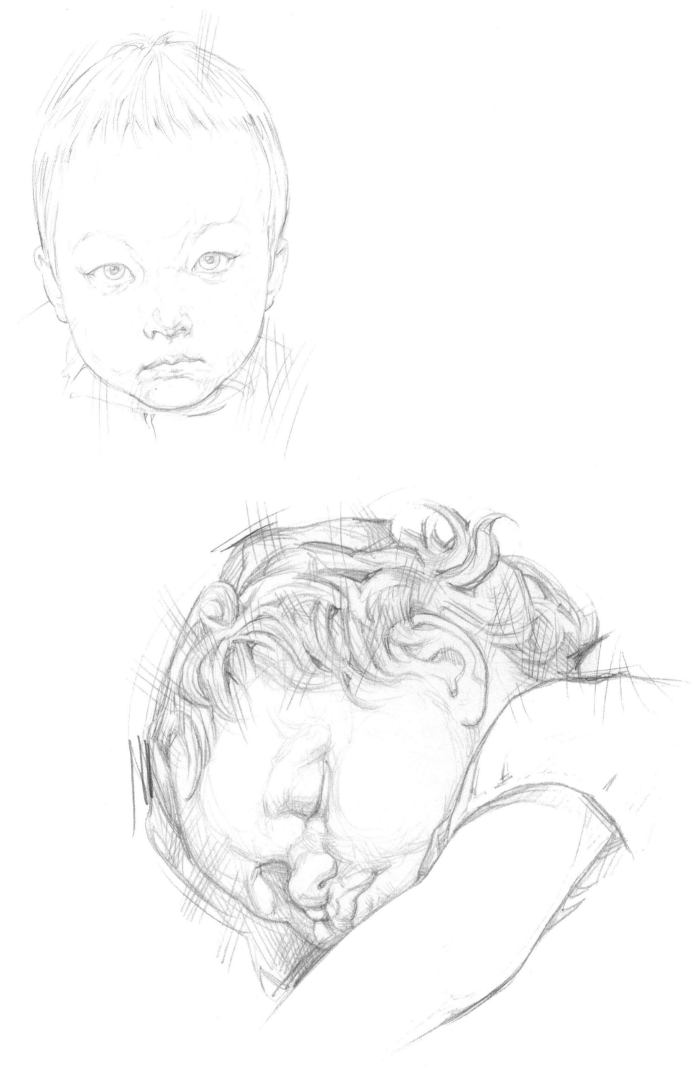

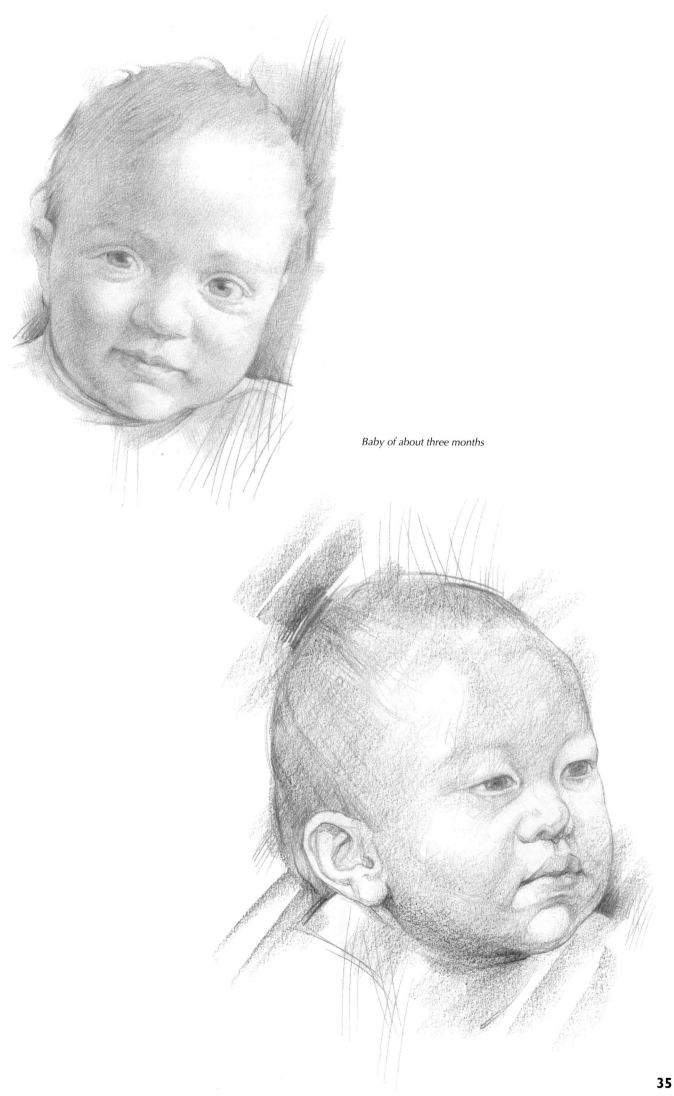

Baby of about three months

When smiling, the base of the nose widens a little and nostrils seem dilated and wider apart. However, in drawings, it is advisable not to emphasise this tendency; indeed, it should be more hinted at than described, using rather light strokes and without shading that is too intense or sharp.

In addition the lips widen and relax when smiling, almost always leaving the front teeth (milk teeth or permanent ones) visible in the position and number dictated by the relative growing phase. After about six years, the permanent upper-central incisors appear rather large in relation to the size of the face and, not uncommonly, a little apart from each other, leaving a gap (diastema) which gives an apparent geniality.

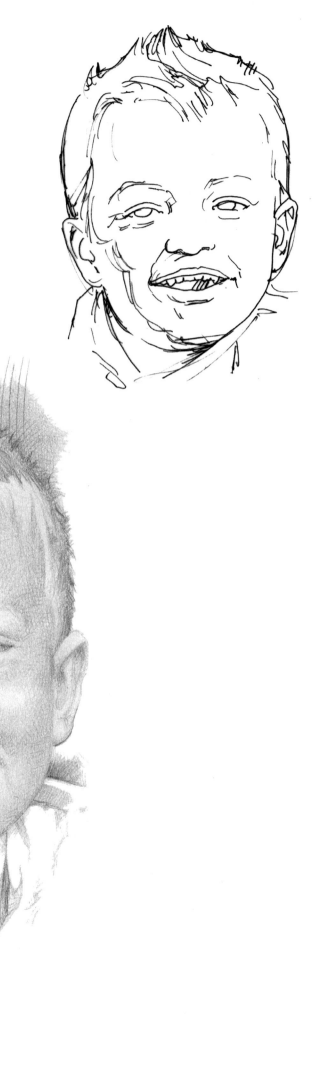

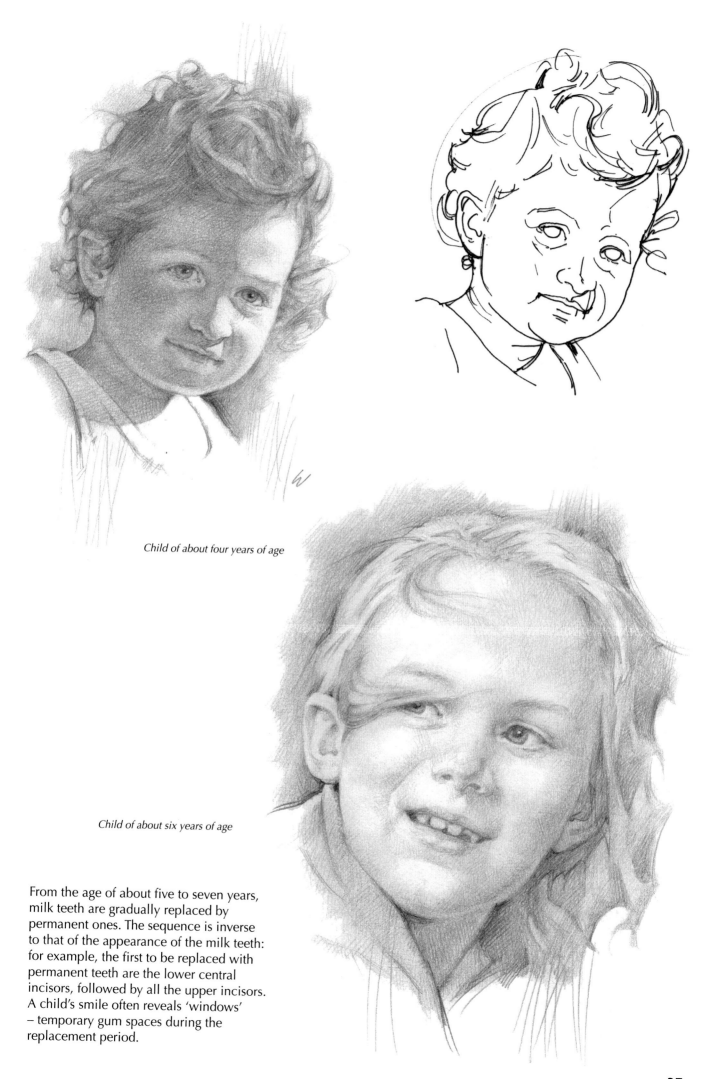

Child of about four years of age

Child of about six years of age

From the age of about five to seven years, milk teeth are gradually replaced by permanent ones. The sequence is inverse to that of the appearance of the milk teeth: for example, the first to be replaced with permanent teeth are the lower central incisors, followed by all the upper incisors. A child's smile often reveals 'windows' – temporary gum spaces during the replacement period.

Child of about four years of age

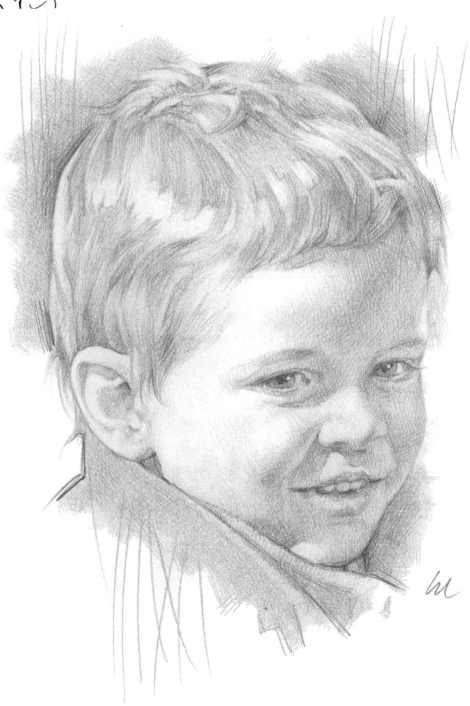

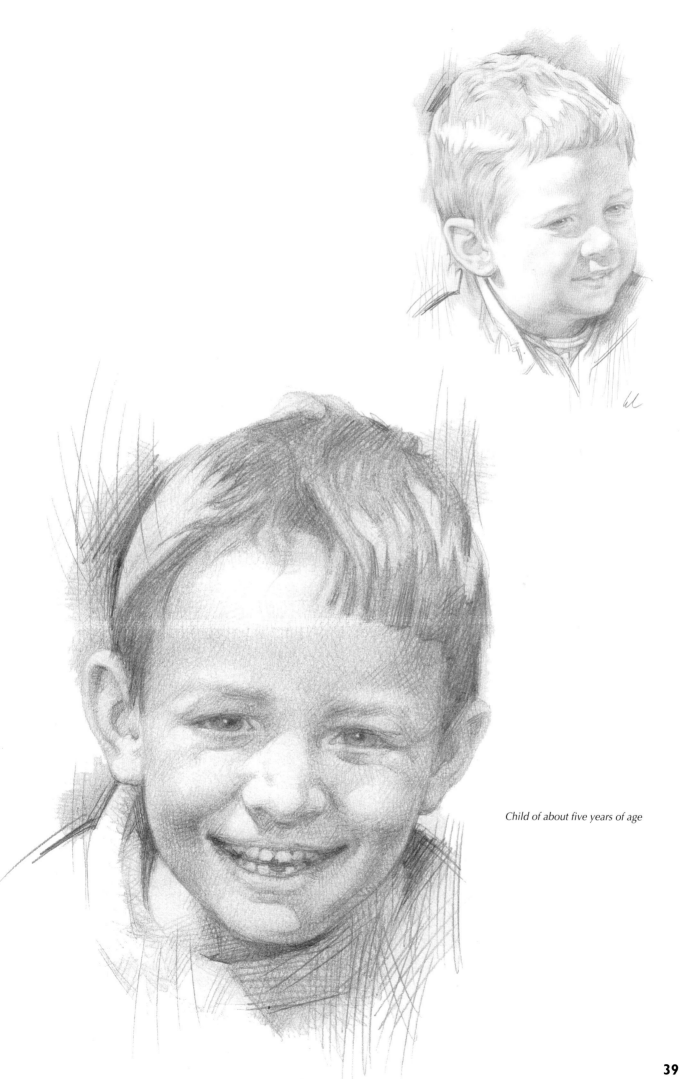

Child of about five years of age

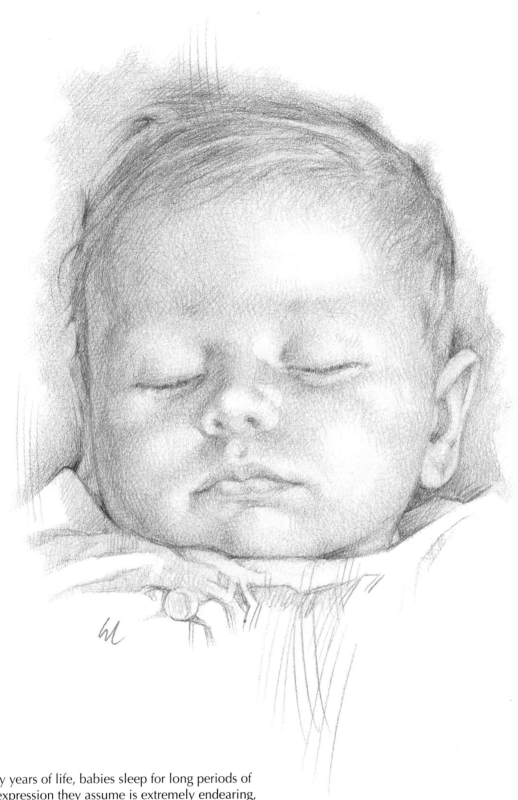

In the early years of life, babies sleep for long periods of time: the expression they assume is extremely endearing, although quite monotonous. However, these moments are perhaps the only ones when they are still long enough to produce an accurate life drawing. The nasolabial groove, which is easy to see in an adult, is totally absent in a baby, as the passage from the upper lip to the convex cheek is very gradual and soft in both volume and blending of tones.

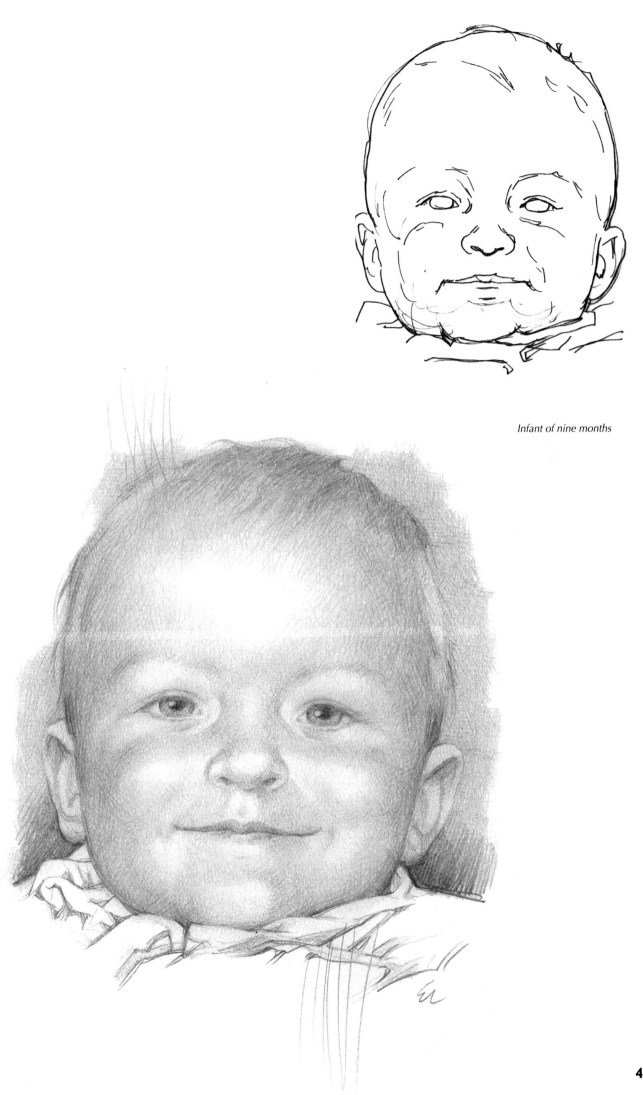

Infant of nine months

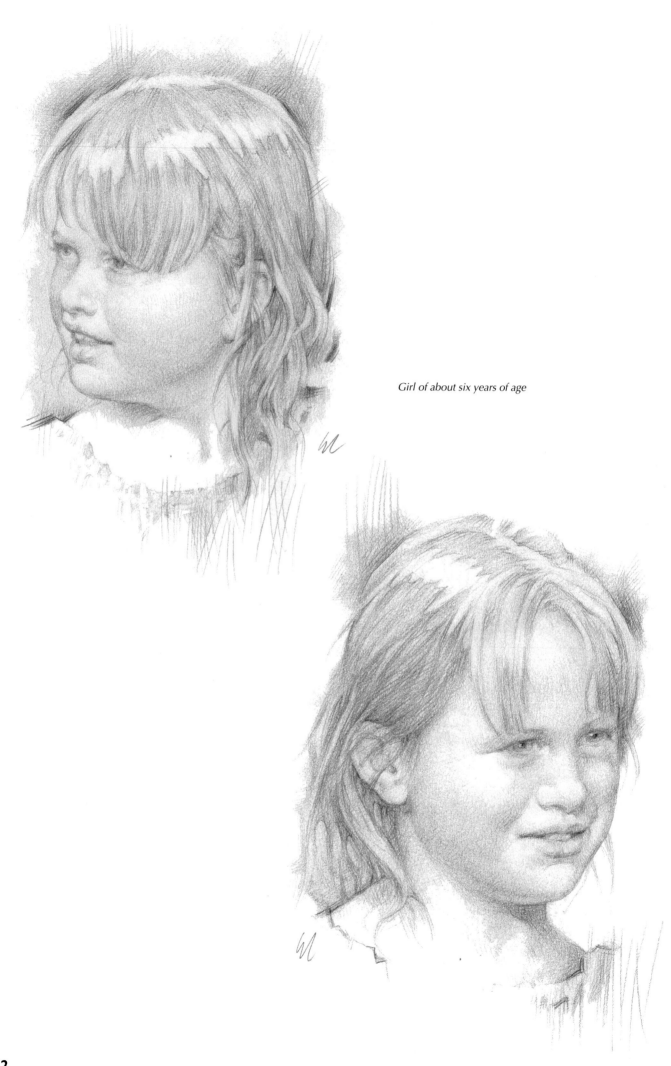

Girl of about six years of age

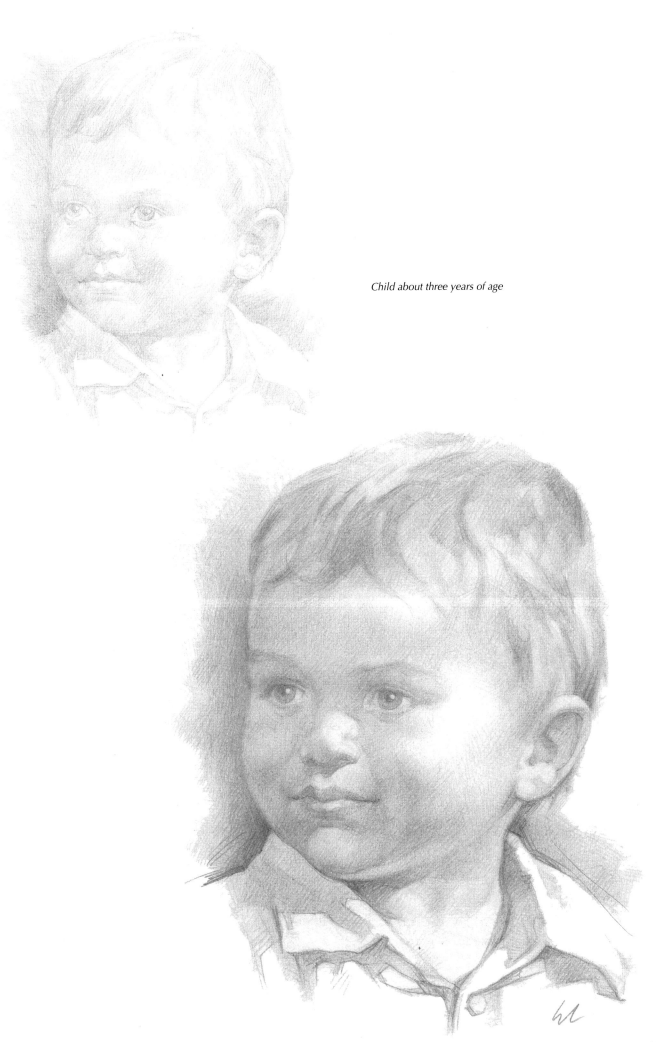

Child about three years of age

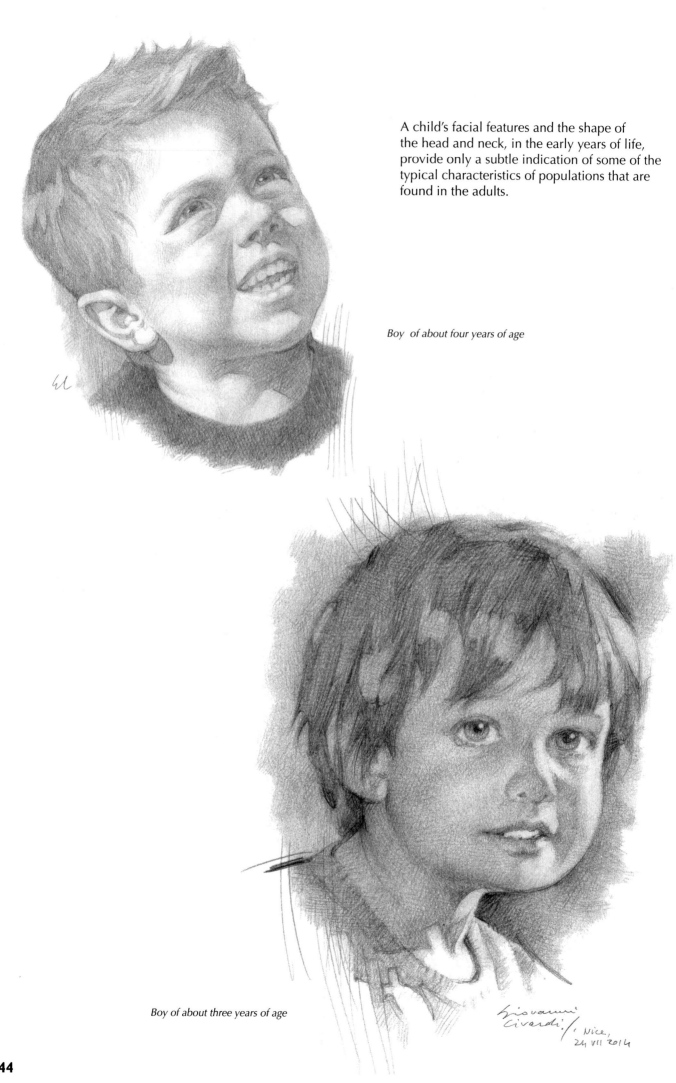

A child's facial features and the shape of the head and neck, in the early years of life, provide only a subtle indication of some of the typical characteristics of populations that are found in the adults.

Boy of about four years of age

Boy of about three years of age

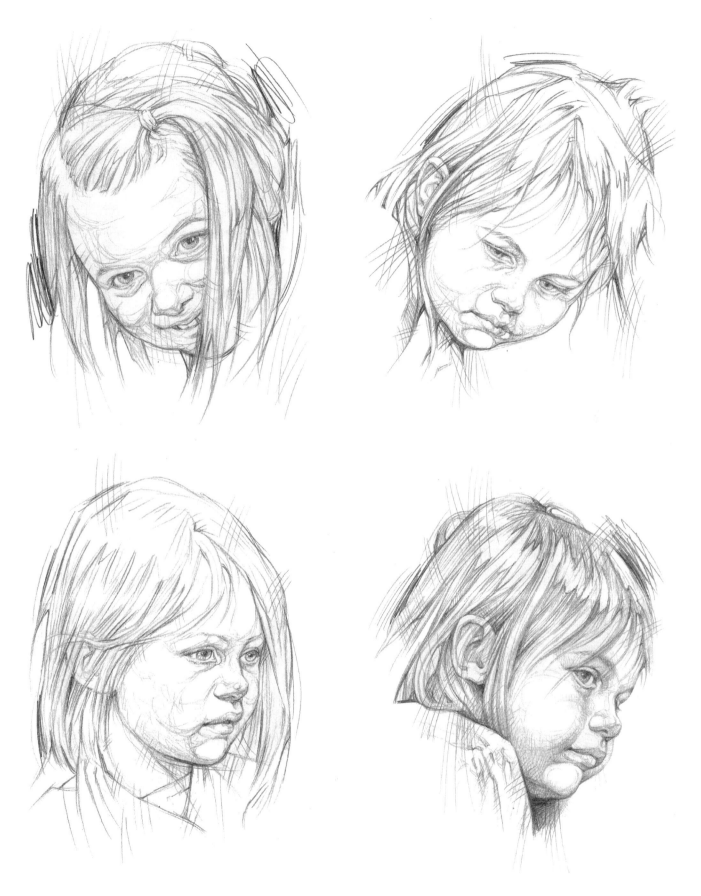

If the young subject (perhaps an adolescent) is a member of the artist's family, or is in any case in the environmental and social conditions to be observed calmly and quietly in various moments and situations, it is a good idea to take advantage of the circumstances and draw some sketches from life in sequence, of varying detail. Line drawings are suitable in these cases as they allow precision, clarity of marks and are quick to complete, while allowing an effective examination of proportions.

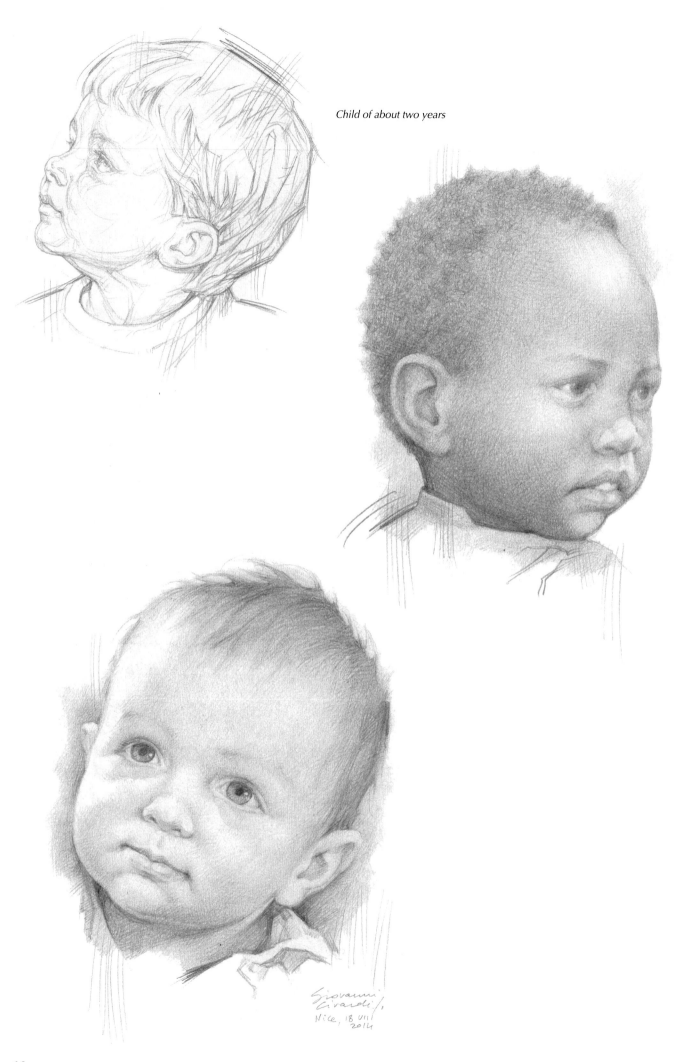

Child of about two years

Giovanni
Civardi,
Nice, 18 VIII
2014

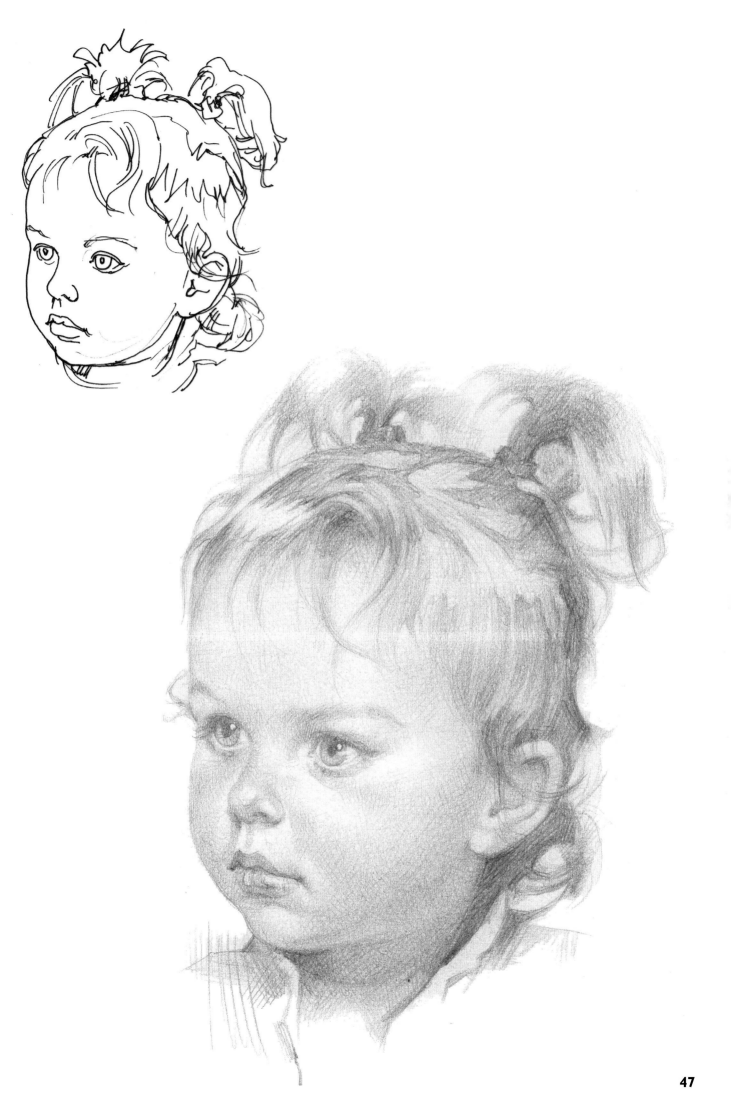

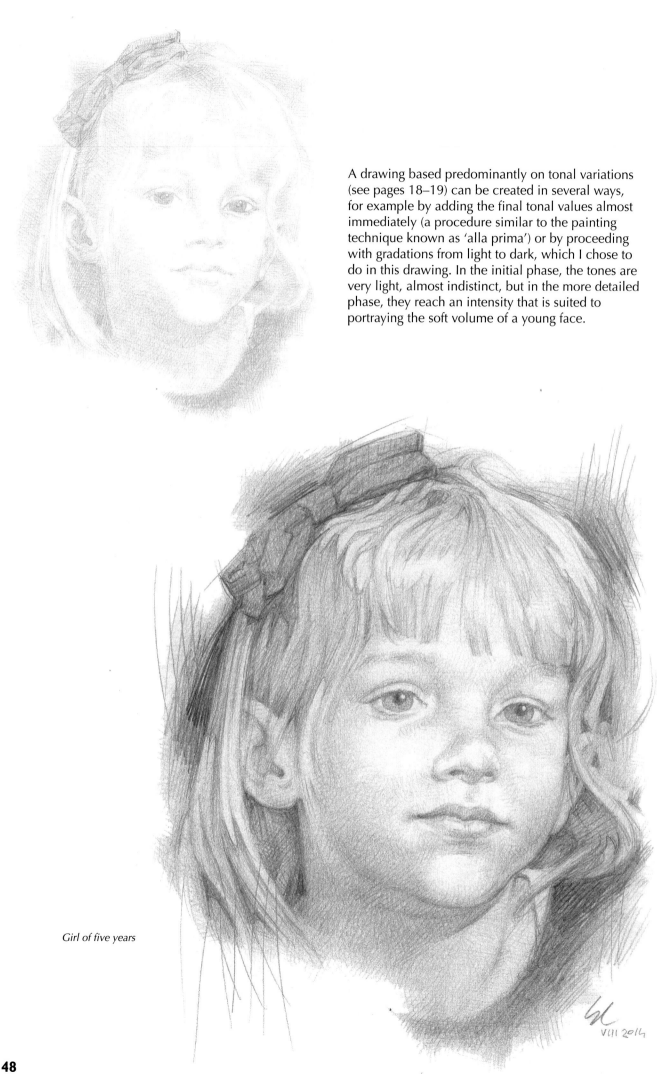

A drawing based predominantly on tonal variations (see pages 18–19) can be created in several ways, for example by adding the final tonal values almost immediately (a procedure similar to the painting technique known as 'alla prima') or by proceeding with gradations from light to dark, which I chose to do in this drawing. In the initial phase, the tones are very light, almost indistinct, but in the more detailed phase, they reach an intensity that is suited to portraying the soft volume of a young face.

Girl of five years

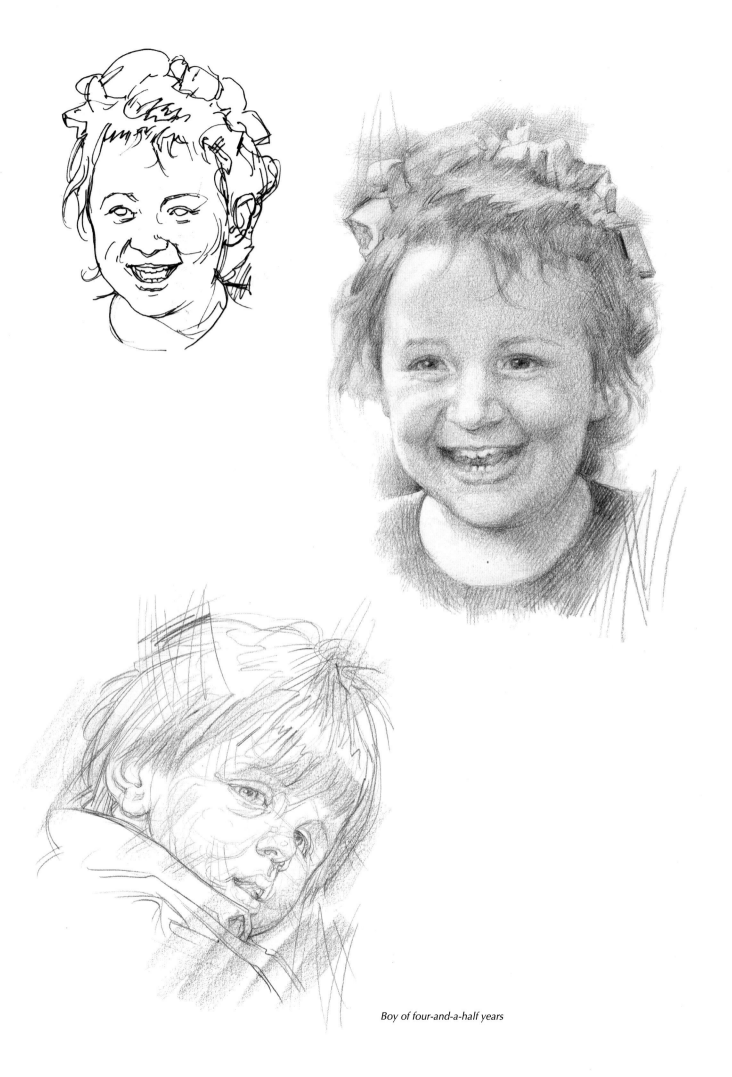

Boy of four-and-a-half years

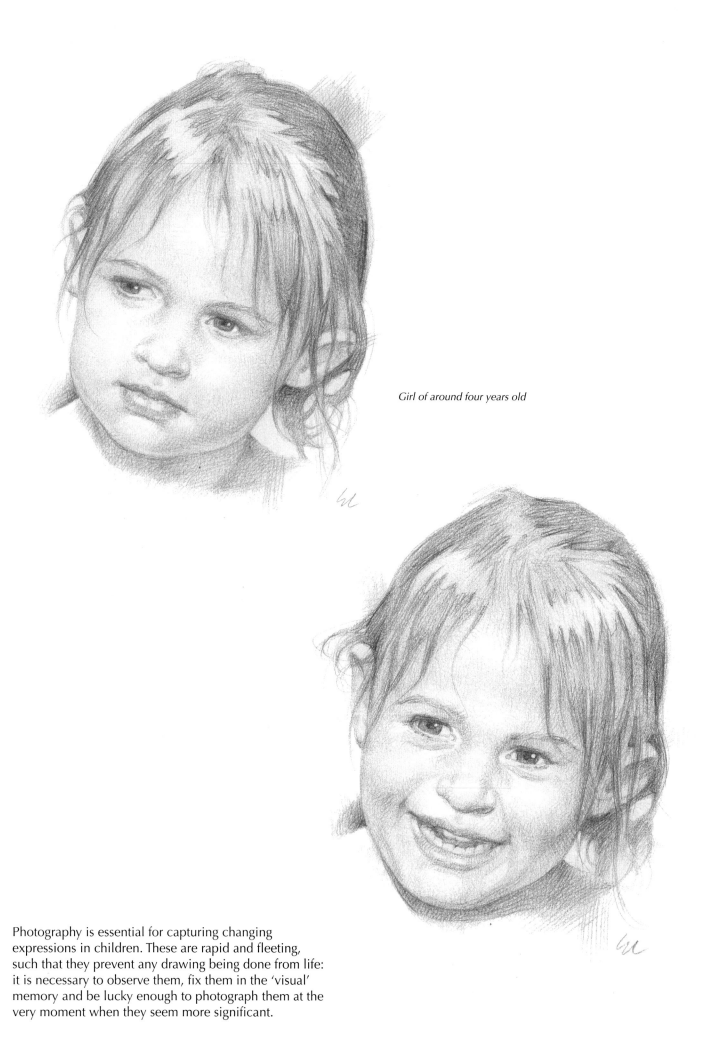

Girl of around four years old

Photography is essential for capturing changing expressions in children. These are rapid and fleeting, such that they prevent any drawing being done from life: it is necessary to observe them, fix them in the 'visual' memory and be lucky enough to photograph them at the very moment when they seem more significant.

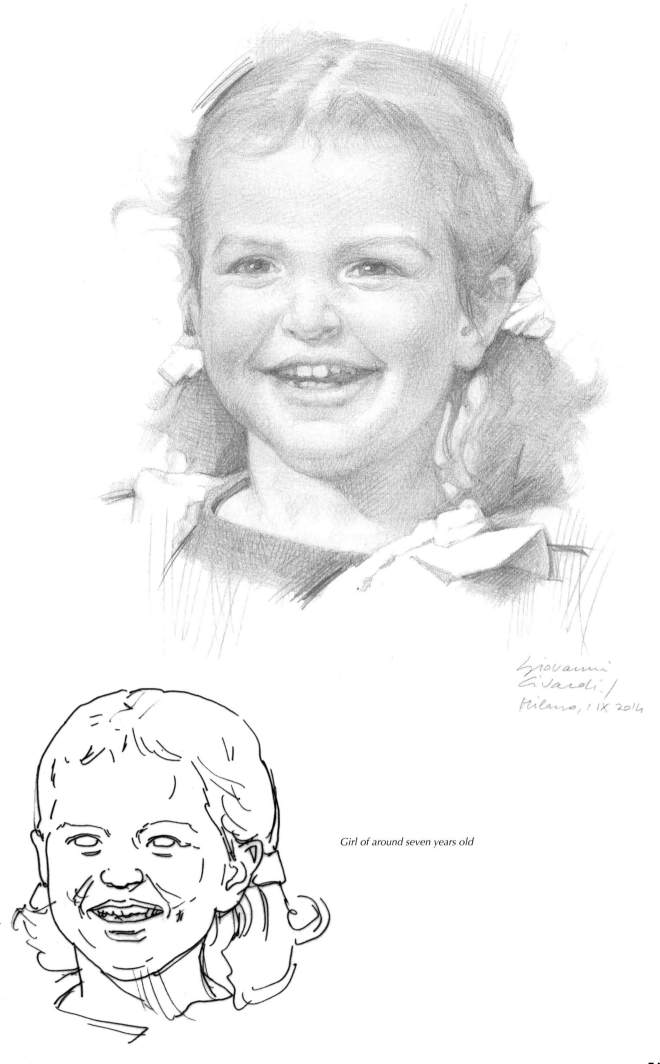

Girl of around seven years old

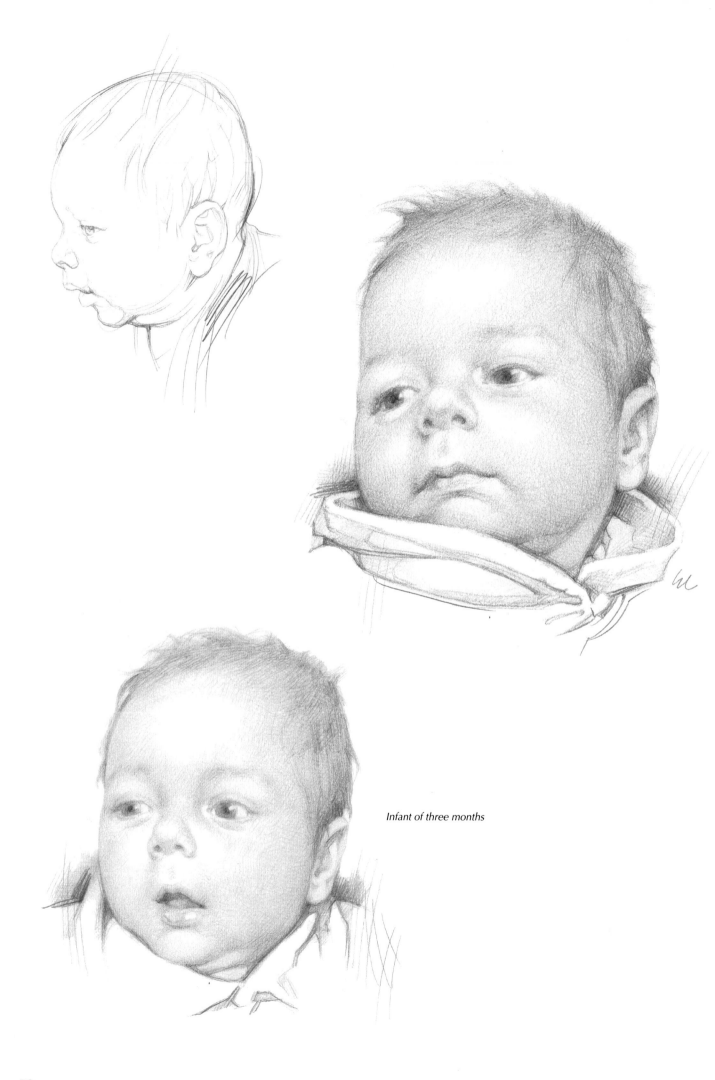

Infant of three months

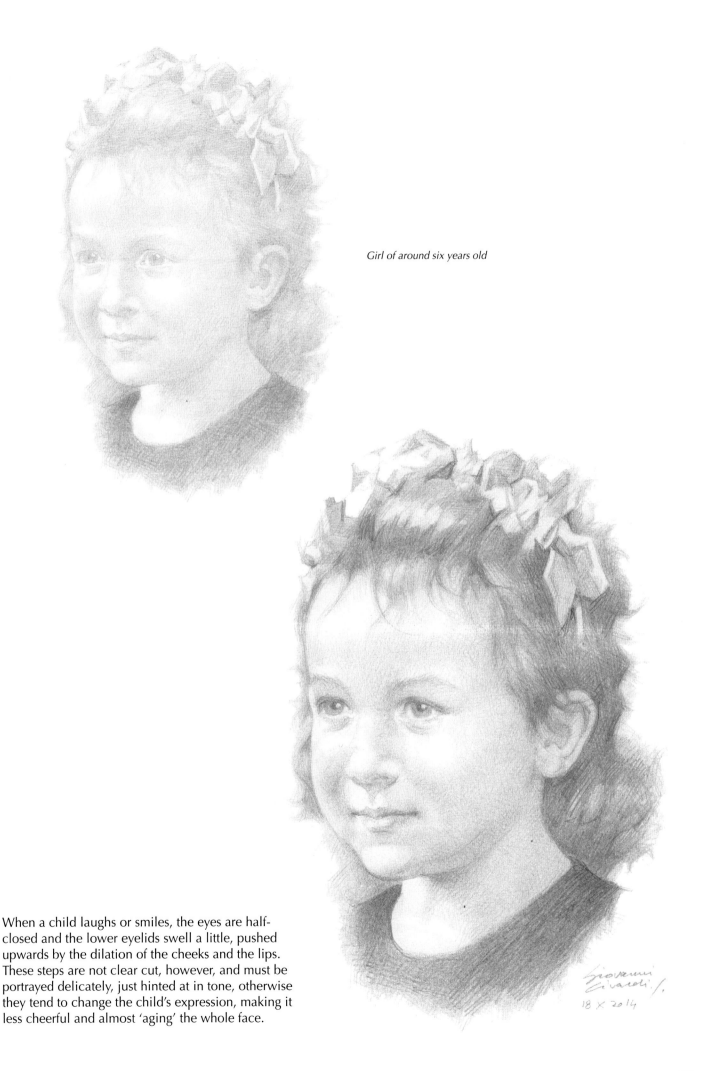

Girl of around six years old

When a child laughs or smiles, the eyes are half-closed and the lower eyelids swell a little, pushed upwards by the dilation of the cheeks and the lips. These steps are not clear cut, however, and must be portrayed delicately, just hinted at in tone, otherwise they tend to change the child's expression, making it less cheerful and almost 'aging' the whole face.

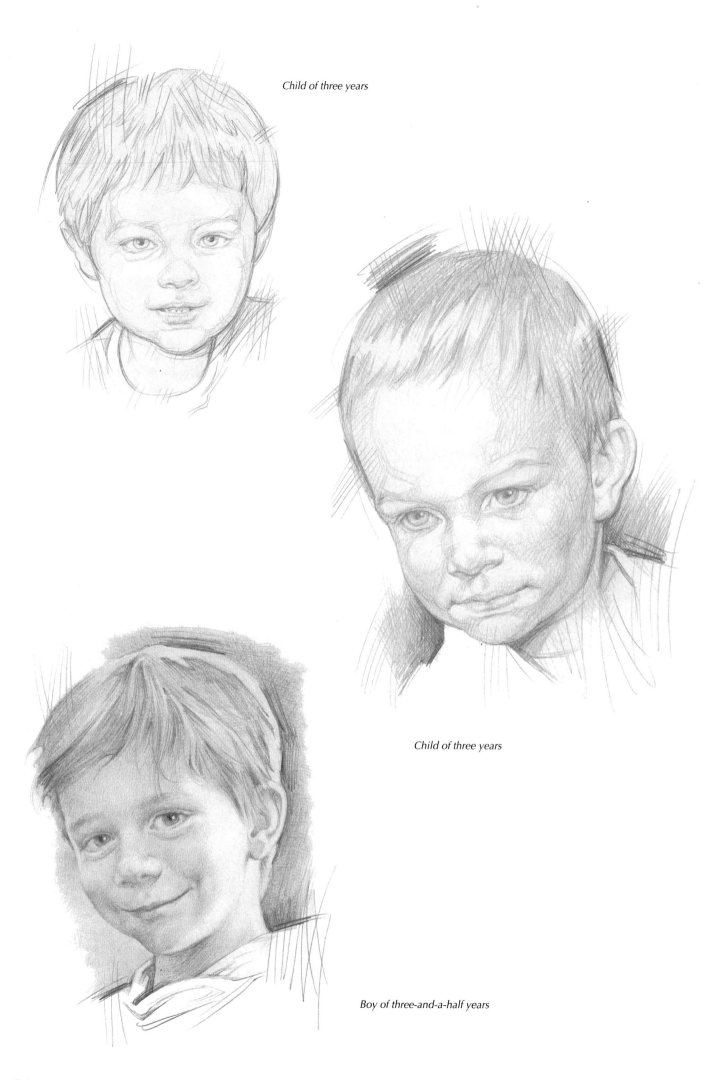

Child of three years

Child of three years

Boy of three-and-a-half years

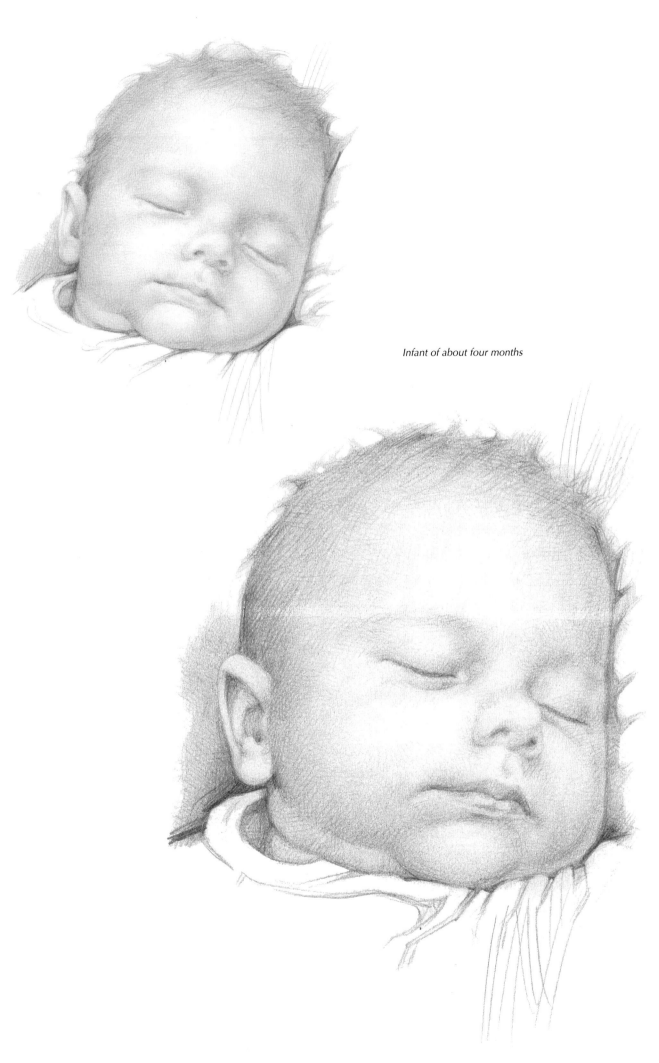

Infant of about four months

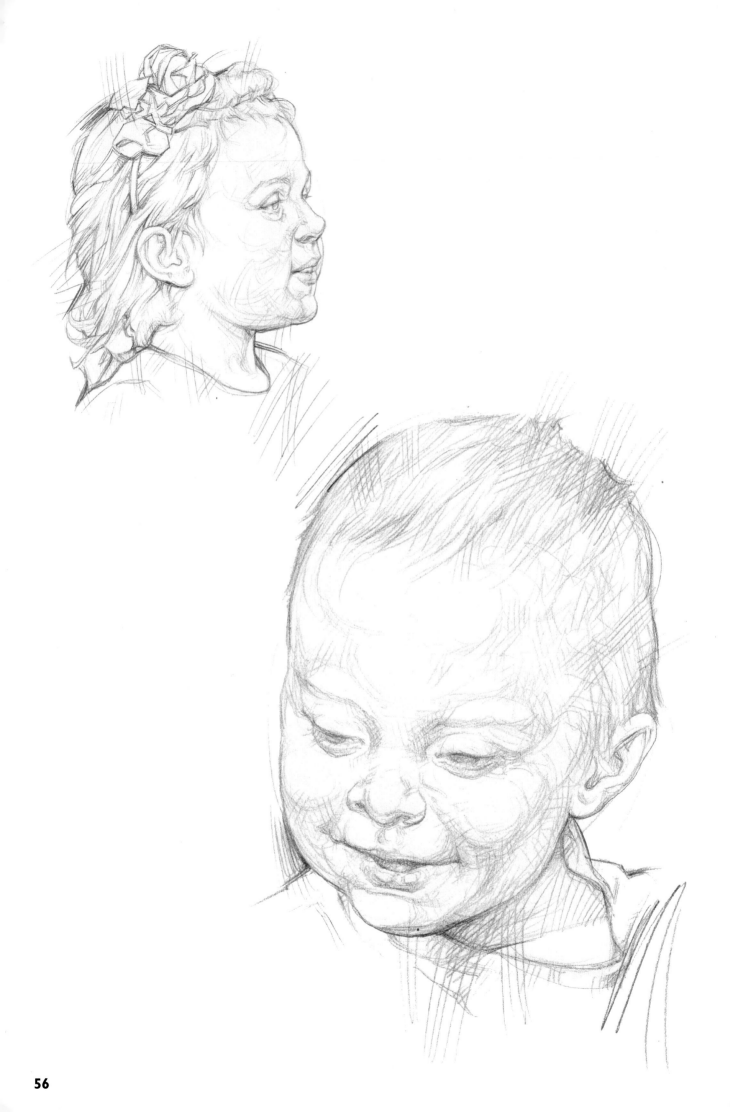

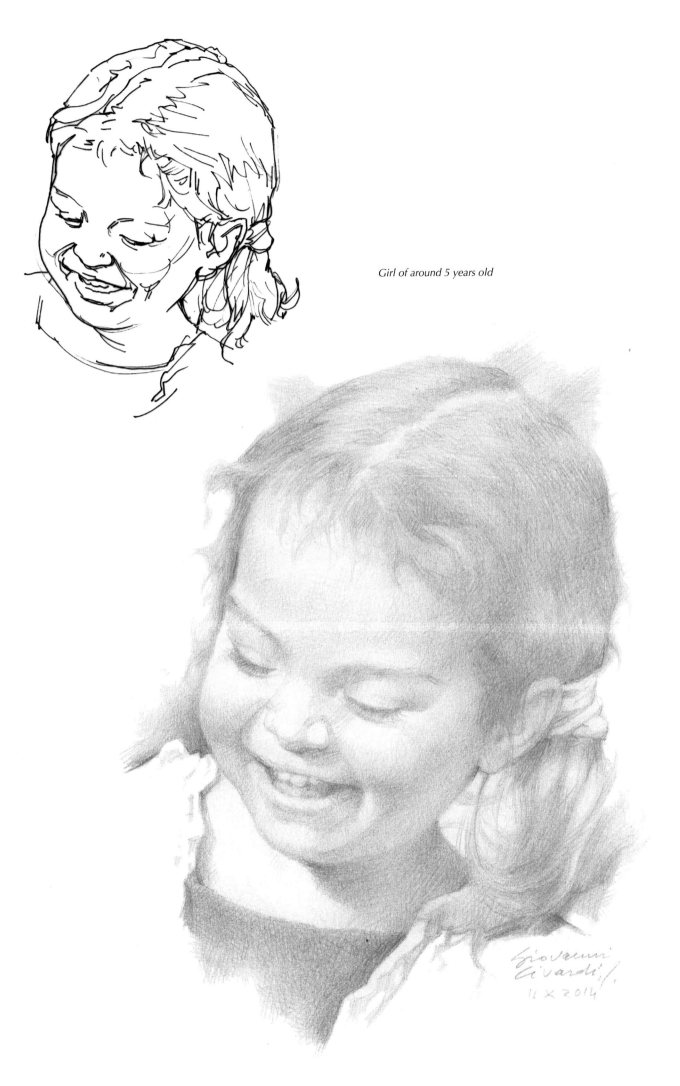

Girl of around 5 years old

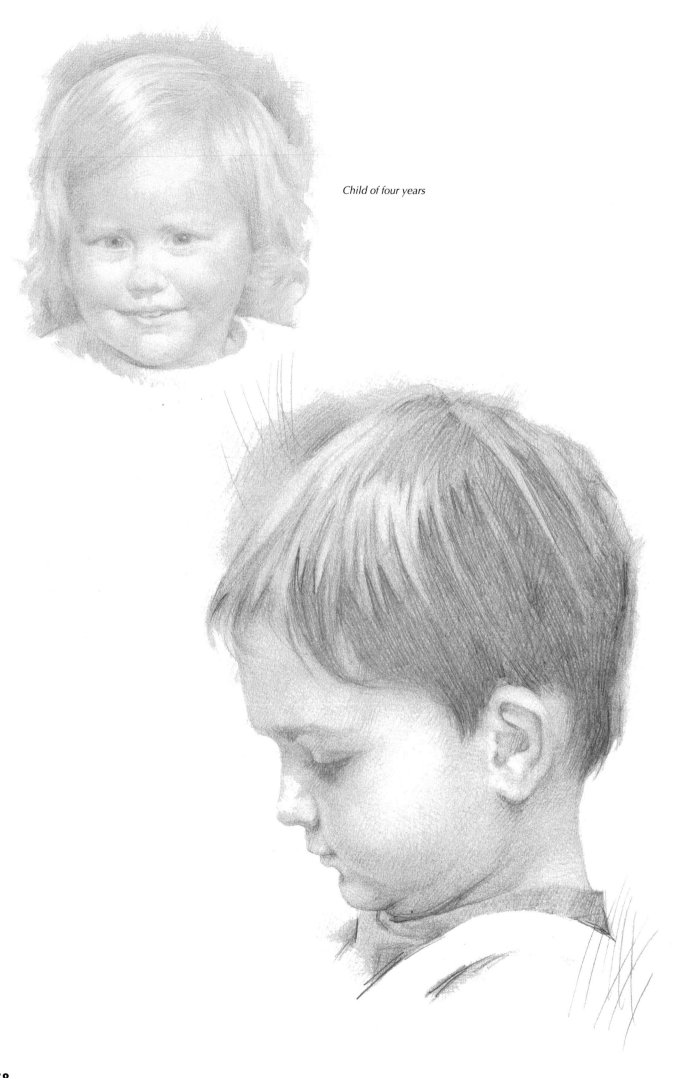

Child of four years

FROM THE FAMILY ALBUM

It is simple to find family photographs in almost all homes. They are perhaps collected in a dusty, well-cared for album, or gathered together in no particular order in envelopes or boxes that have been relegated to a corner of the attic. In recent years, documentation of family life has been entrusted to the various forms of digital technology, to be consulted on a computer screen or television but, until a few years ago, photographs printed on paper, especially in black and white, were the norm and often rather exceptional quality. In fact, only the most important life events, holidays or new births deserved a photo, to preserve the memory. These photographs evoke emotions, due to their 'ancient' appearance, with studied lighting and pose, 'professional' in their aesthetic aspect. It is therefore enjoyable (and a little nostalgic) to pick out a few family features in the children's or young faces from our old photographs: parents, grandparents, playmates, a few ancestors or even ourselves. In many cases, it is possible to go back several decades with these images. They may also be more recent, but still 'dated' in their external fashions. In this way we can discover interesting and curious physical features, expressions, attitudes, hairstyles and clothes, from the past: all aesthetic stimuli that can make the portraiture of children even more exciting.

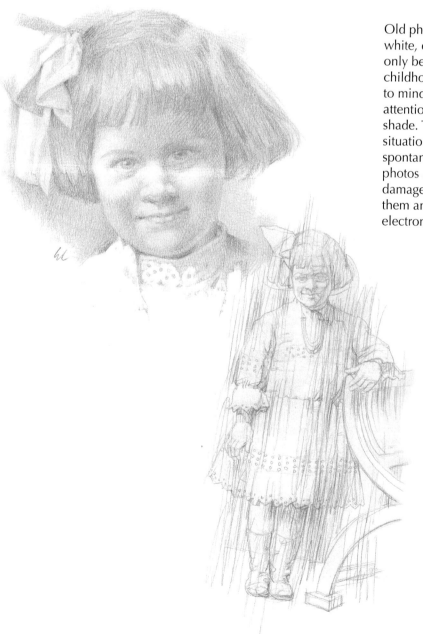

Old photographs that were printed in black and white, or sepia, have a certain fascination, not only because they have a vintage feel, or bring our childhood image, or those of near and dear ones, to mind, but also because the lack of colour draws attention to shape and the modulation of light and shade. The 'instant' image is a document of a casual situation, which almost always captures fleeting, spontaneous or naïve expressions. If the original photos are small or faded and you do not want to damage them, it is now possible to digitally scan them and further define the faces with the use of electronic tools and computer programmes.

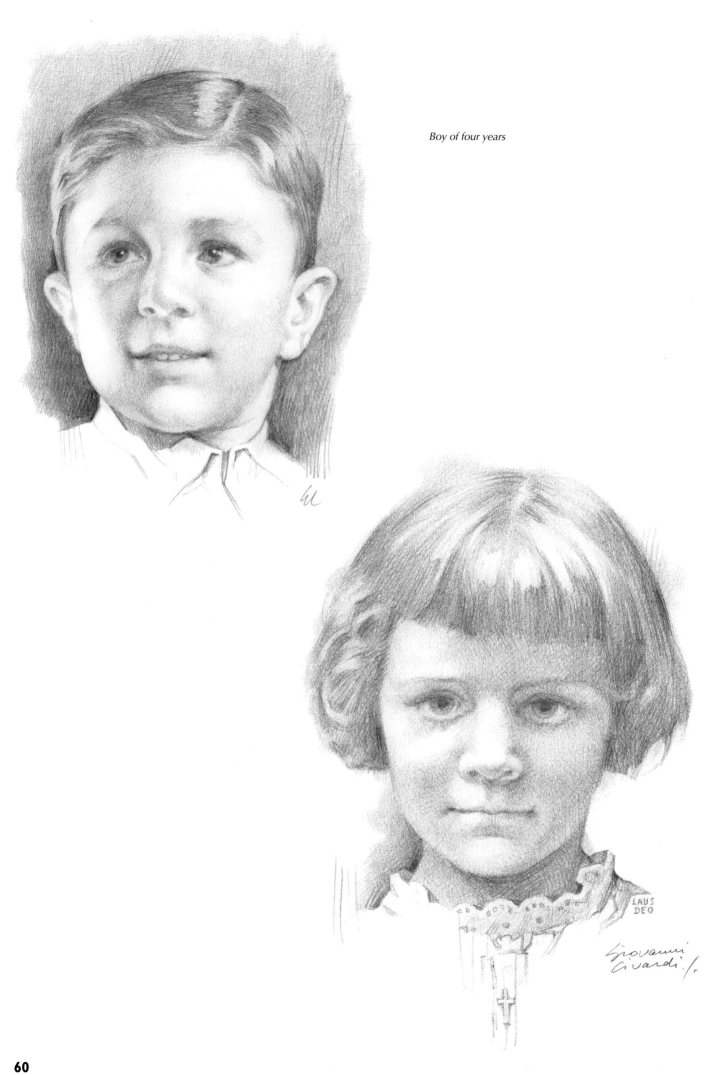

Boy of four years

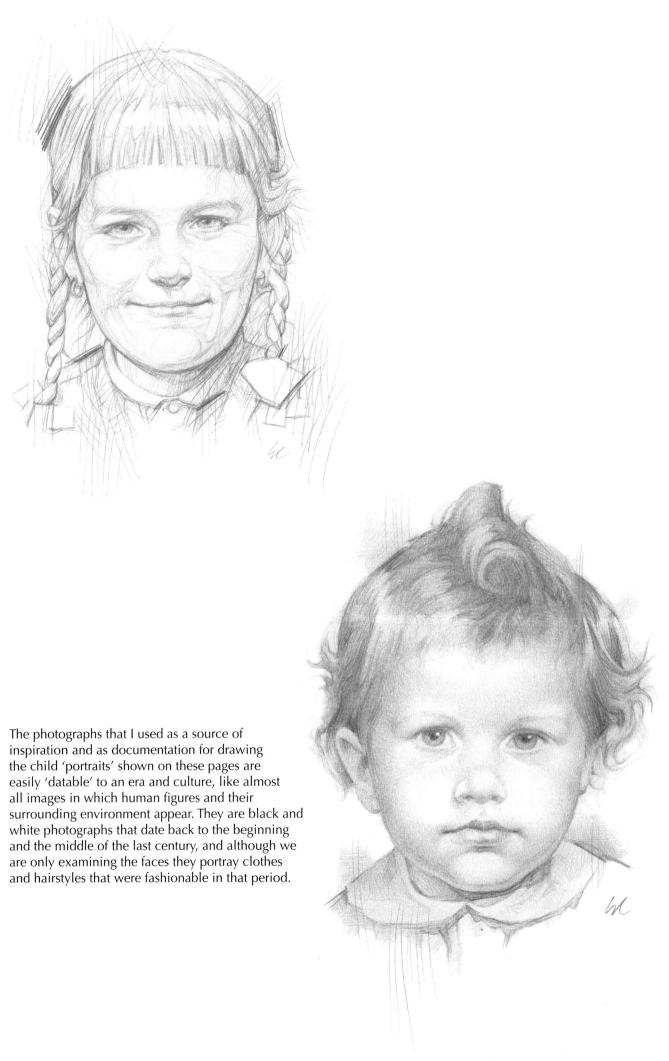

The photographs that I used as a source of inspiration and as documentation for drawing the child 'portraits' shown on these pages are easily 'datable' to an era and culture, like almost all images in which human figures and their surrounding environment appear. They are black and white photographs that date back to the beginning and the middle of the last century, and although we are only examining the faces they portray clothes and hairstyles that were fashionable in that period.

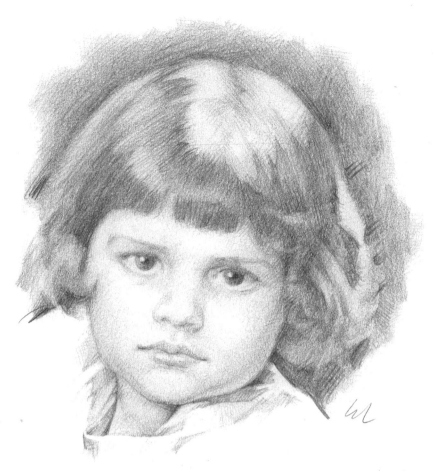

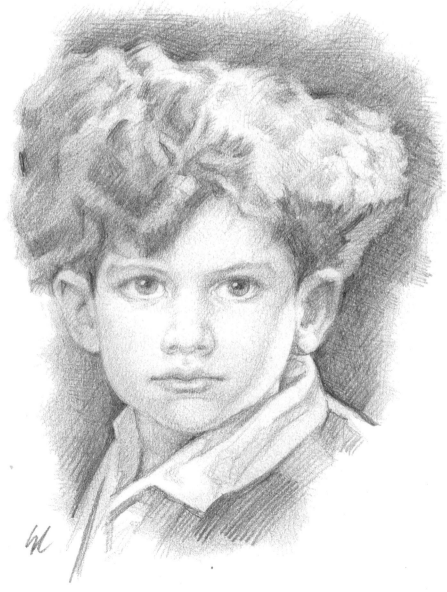

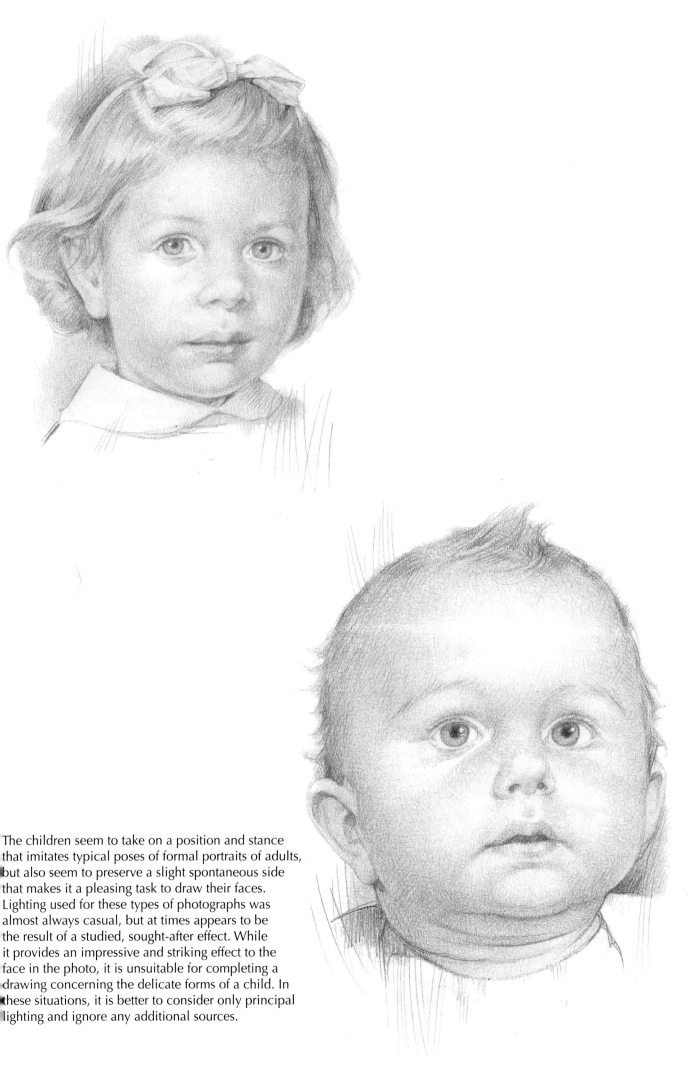

The children seem to take on a position and stance that imitates typical poses of formal portraits of adults, but also seem to preserve a slight spontaneous side that makes it a pleasing task to draw their faces. Lighting used for these types of photographs was almost always casual, but at times appears to be the result of a studied, sought-after effect. While it provides an impressive and striking effect to the face in the photo, it is unsuitable for completing a drawing concerning the delicate forms of a child. In these situations, it is better to consider only principal lighting and ignore any additional sources.

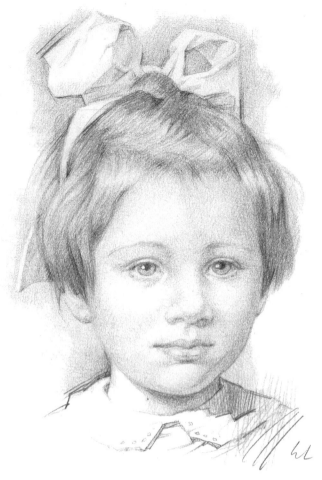

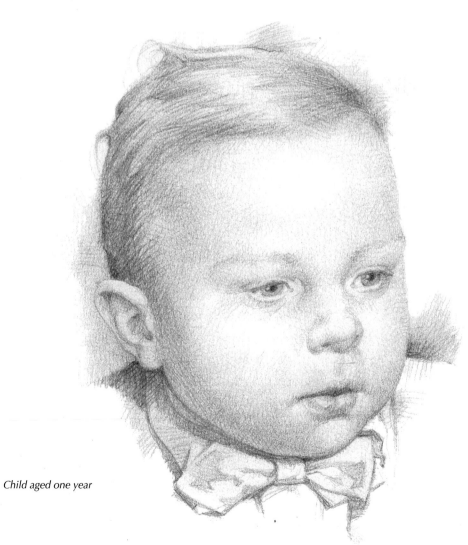

Child aged one year